A VERY LIQUID HEAVEN

Library of Congress Cataloging-in-Publication Data

Berry, Ian, 1971–
 A very liquid heaven / Ian Berry, Margo Mensing,
 Mary Crone Odekon; with essays by Margaret
 J. Geller ... [et al.] ; artists' dialogue by Ian Berry.
 p. cm.
 Catalog of an exhibition at the Frances Young Tang
 Teaching Museum and Art Gallery at Skidmore
 College, Oct. 23, 2004–June 5, 2005.
 Includes bibliographical references.
 ISBN-13: 978-0-9725188-6-4 (hardcover: alk. paper)
 ISBN-10: 0-9725188-6-X (hardcover.: alk. paper)
 1. Art and science—Exhibitions. 2. Astronomy in
 art—Exhibitions. I. Mensing, Margo, 1941–
 II. Odekon, Mary Crone. III. Frances Young Tang
 Teaching Museum and Art Gallery. IV. Title.
N72.S3B47 2005
701'.05'07474748—dc22

2005025112

A VERY LIQUID HEAVEN

Ian Berry
Margo Mensing
Mary Crone Odekon

WITH ESSAYS BY
Margaret J. Geller and Scott J. Kenyon
Margo Mensing
Mary Crone Odekon
Matthew Wilson

ARTISTS' DIALOGUE BY
Ian Berry

THE FRANCES YOUNG TANG TEACHING MUSEUM
AND ART GALLERY AT SKIDMORE COLLEGE

CONTENTS

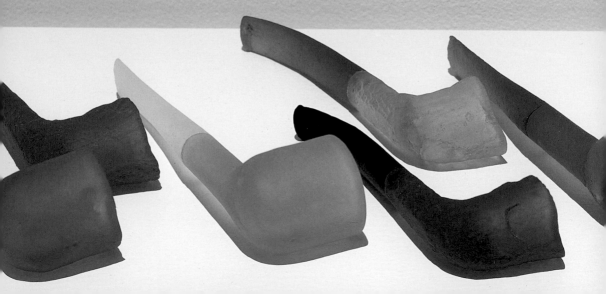

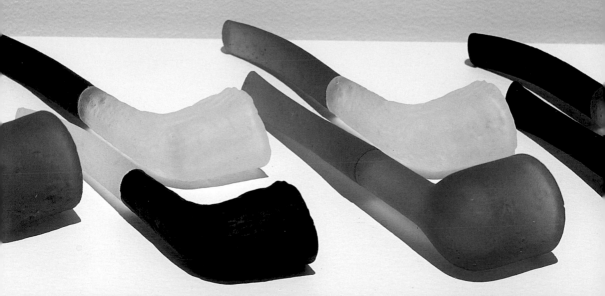

FOREWORD

WHEN *A VERY LIQUID HEAVEN* **WAS FIRST DESCRIBED TO ME**—well before I had come to the Tang last year—I had a difficult time imagining how a show combining works as diverse as a recent Slater Bradley video and Galileo's early seventeenth-century books documenting astronomical observations could possibly work, and I was more than a bit skeptical. Now, nearly a year later, my reservations seem quaint, and perhaps faint-hearted. Thanks to the combined efforts of Tang curator Ian Berry and Skidmore faculty members Margo Mensing in Studio Art and Mary Crone Odekon in Physics, *A Very Liquid Heaven* has been a brilliantly modulated, elegant, playful, and satisfying aesthetic and intellectual experience.

Neither precisely an art show, nor a science history exhibit, *A Very Liquid Heaven* is an open-ended and open-minded rethinking of how art and science can coexist in an exhibition. It is therefore a superb example of what the Frances Young Tang Teaching Museum and Art Gallery at Skidmore College was founded to do, and it has been the perfect show to have here in my first year as Dayton Director of the Tang.

It is significant that *A Very Liquid Heaven* was created by a scientist, an artist, and a curator, for that crossing of disciplinary boundaries is central to the Tang's mission. It is also fascinating to note that the exhibition itself began life as a by-product of an evening of twentieth-century classical music, namely George Crumb's *Makrokosmos III*, blossoming into a full-fledged, year-long gallery show only when it became clear how rich a topic the "very liquid heaven" was for an interdisciplinary journey.

My thanks and congratulations to Margo, Mary, and Ian for such a productive collaboration, and many thanks also to David Porter for getting the Makrokosmos ball rolling in the first place. Thanks also to all of the Tang staff whose good work made the performance and exhibition possible, and to the many actors, musicians and artists involved. This was a labor of love and invention, enjoyed by thousands of visitors over the course of its run at the Tang.

JOHN WEBER
DAYTON DIRECTOR

this page and following two spreads:

GEORGE CRUMB

Notes and score to Music For A Summer

Evening (Makrokosmos III), 1974

Pencil and ink on paper

Each sheet, 11 x 15 1/8 inches

Collection of George Crumb, Media, Pennsylvania

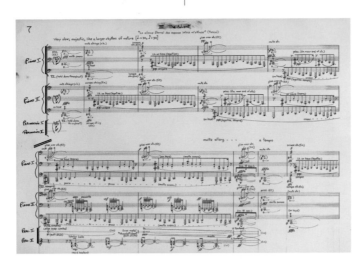

[Music for a Summer Evening, A.D. 1942]
(for 2 Amplified Pianos and 2 Percussionists)
[for Gil Kalisch and Jim Freeman]
comn. Fromm Foundation

"Und in den Nächten fällt die
fallen. Und doch ist Einer, welcher dieses

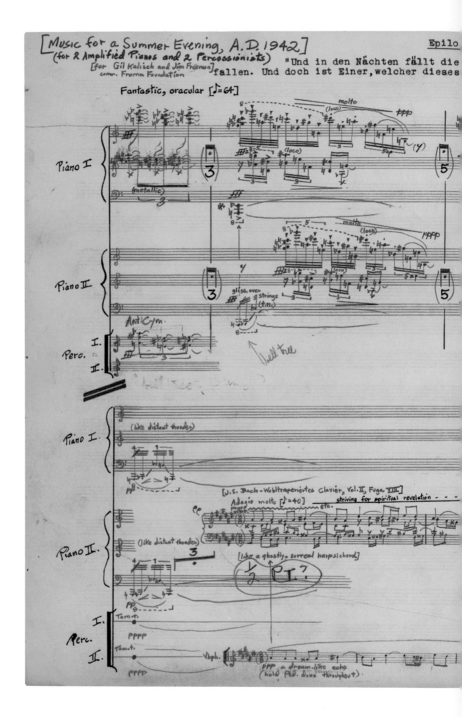

re Erde aus allen Sternen in die Einsamkeit. Wir alle
n unendlich sanft in seinen Händen hält." [Rilke: Das Buch der Bilder]

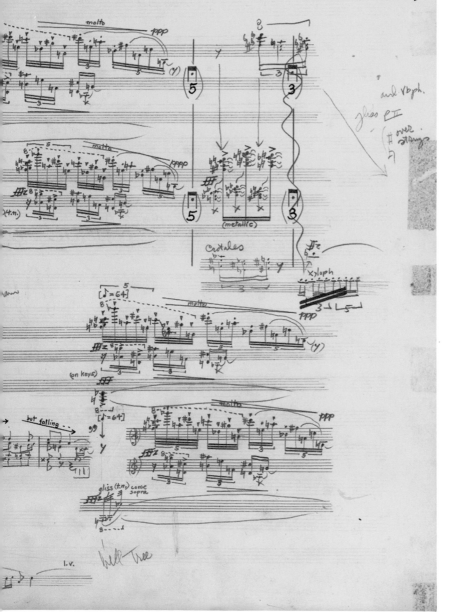

MAK3

A Musical Event Preceded by a Cocktail Party and Special Guest Interviews

7 PM, OCTOBER 14, 15, AND 17, 2004

PROGRAM

ACT 1

Charles and Ray Eames invite you to a cocktail party

ACT 2

Interviews
EDWIN HUBBLE, RAINER MARIA RILKE,
RAY EAMES, HENRIETTA LEAVITT,
CHARLES EAMES

ACT 3

Music for a Summer Evening (Makrokosmos III) for Two Amplified Pianos and Percussion [Two Players]
BY GEORGE CRUMB

I. NOCTURNAL SOUNDS (THE AWAKENING)
II. WANDERER-FANTASY
III. THE ADVENT
IV. MYTH
V. MUSIC OF THE STARRY NIGHT

RICHARD HIHN, DAVID PORTER
RICHARD ALBAGLI, SCOTT STACEY

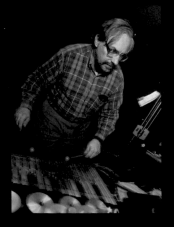

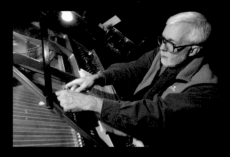

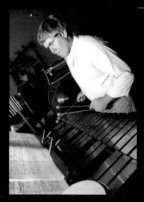

HOSTED BY CHARLES AND RAY EAMES, the
evening musical event begins with a cocktail party.
The party illuminates the universe in a setting that
the Eameses might conjure. Outside, a dozen per-
formers in white jumpsuits, "The Physicists," move
through the landscape. Here, then there, their
flickering light is seen through the doors and win-
dows of the Tang Museum. Charles and Ray wel-
come guests into the atrium. Many gather around a
large table covered with a cloth Ray designed and
printed. In her abstraction of the Tarantella
Nebulae in the Large Magellanic Cloud, stars hover
in fiery explosions of gas and dust millions of miles
beyond the Milky Way.

Special guests Edwin Hubble, Henrietta
Leavitt and Rainer Maria Rilke arrive. For a few
minutes the room is awash in conversation. The
convivial chatter dies down as the sound of the cos-
mic microwave background pervades the party. The
interviewer takes her place. One by one, the
Eameses, Hubble, Henrietta Leavitt and Rilke step
into the booth in the vestibule, respond to her
questions, tell their stories.

Then Charles and Ray invite their guests
into the Wachenheim Gallery to listen to pianists
Richard Hihn and David Porter and percussionists
Richard Albagi and Scott Stacey perform *Music for a
Summer Evening (Makrokosmos III)*. Written for two ampli-
fied pianos and percussion in five movements,
George Crumb's *Makrokosmos III* premiered at
Swarthmore College in 1974.

Crumb describes the instruments and his
inventions: *"The combination of two pianos and percus-
sion instruments was, of course, first formulated by
Béla Bartók in his Sonata of 1937... Bartók was one of
the very first composers to write truly expressive pas-
sages for the percussion instruments; since those days
there has been a veritable revolution in percussion tech-
nique and idiom and new music has inevitably assimilat-
ed these developments.*

*The battery of percussion instruments required
for* Summer Evening *is extensive and includes vibra-
phone, xylophone, glockenspiel, tubular bells, crotales
(antique cymbalos), bell tree, claves, maracas, sleigh-
bells, wood blocks and temple blocks, triangles, and sev-
eral varieties of drums, tam-tams, and cymbals. Certain
rather exotic instruments are occasionally employed
for their special timbral characteristics: two slide whis-
tles, a metal thunder-sheet, African log drum, quijada*

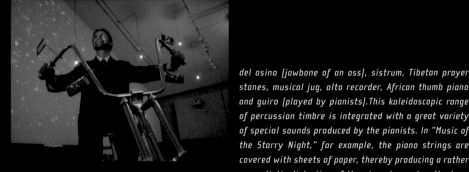

del asino (jawbone of an ass), sistrum, Tibetan prayer stones, musical jug, alto recorder, African thumb piano and guiro (played by pianists).This kaleidoscopic range of percussion timbre is integrated with a great variety of special sounds produced by the pianists. In "Music of the Starry Night," for example, the piano strings are covered with sheets of paper, thereby producing a rather surrealistic distortion of the piano tone when the keys are struck.

As in several of my other works, the musical fabric of Summer Evening results largely from the elaboration of tiny cells into a sort of mosaic design. I feel that Summer Evening projects a clearly articulated large expressive curve over its approximately forty-minute duration."

The performance takes place in the round. The Eames-design bleachers with Ray's silk screened cushions provide excellent views from anywhere in the gallery.

This collaboration evolved out of the *Satie Saga Tango* presented at

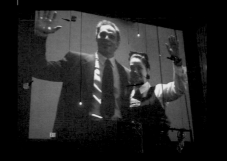

CAST

Designed and Directed by: Debra Fernandez
and Margo Mensing
Choreography: Debra Fernandez
Script: Margo Mensing
Costumes: Kim Vanyo
Film: Tarvis Watson

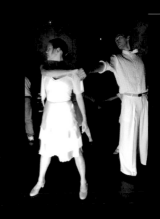

MUSICIANS:
Percussion: Richard Albagli
Piano: Dick Hihn
Piano: David Porter
Percussion: Scott Stacey

ACTORS:
Rainer Maria Rilke: David Barlow
Henrietta Swan Leavitt: Jesse Hawley
Ray Eames: Valerie Issembert
Charles Eames: David Pilot
Edwin Hubble: James Stanley

DANCERS:
The Wanderers:
Francesca Eishenhauer
Julie Gedalecia
Devin Johnson
Sam Johnson

Nut (Ancient goddess of the sky):
Melissa Pomeroy

The Physicists:
(Students of Debra Fernandez's
Fall 2004 Contemporary Dance Workshop)
Alison Berg
Marissa Carr
Alicia McGaw Doyle
Zahra Garrett
Ellen Goldstein
Catlin Hinz
Dyani Johns
Sasha Lehrer
Mark Schou
Carolyn Seiden
Lucy Struever

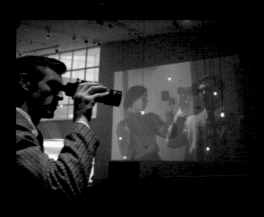

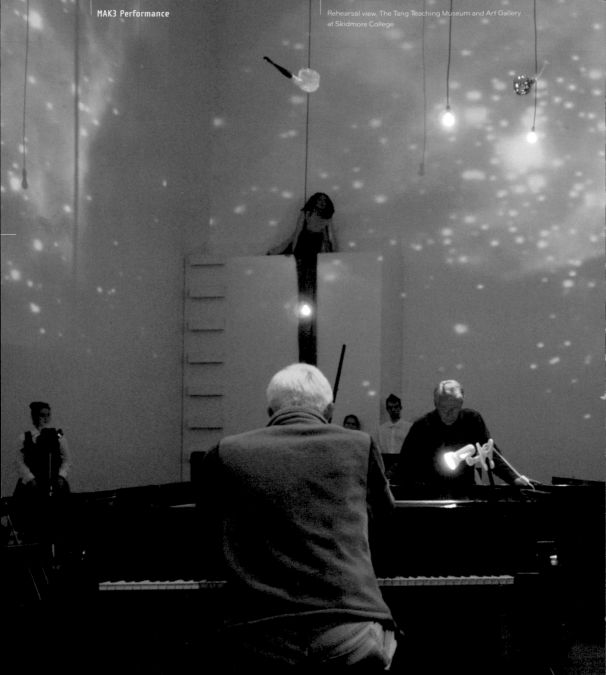

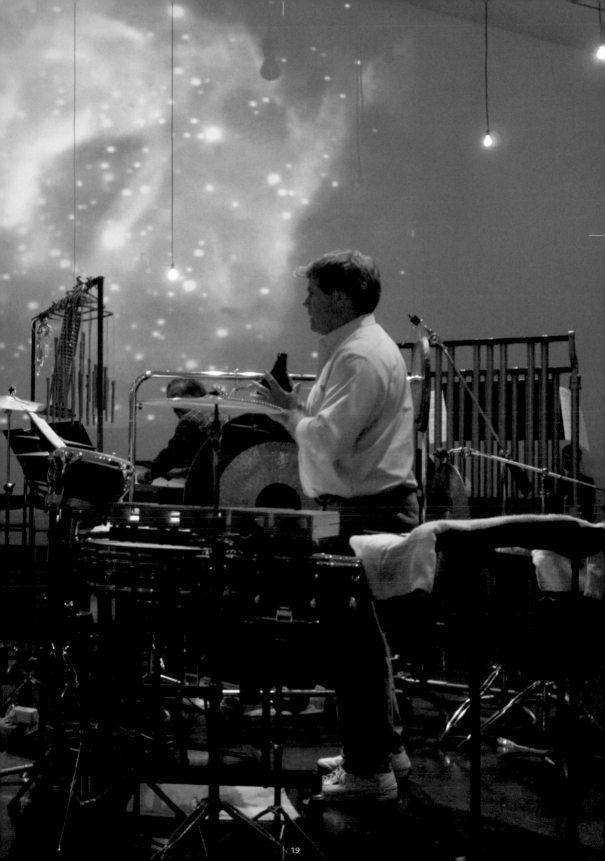

EDWIN HUBBLE

THE FOLLOWING FIVE INTERVIEWS, WRITTEN AND CONDUCTED
DURING THE MAK3 PERFORMANCE BY MARGO MENSING,
JOIN THE WORDS AND HISTORIES OF RAY AND CHARLES EAMES, EDWIN HUBBLE,
HENRIETTA LEAVITT AND RAINER MARIA RILKE
WITH FICTIONAL MUSINGS.

INTERVIEWER: Edwin, do you mind if I call you Edwin?

EDWIN HUBBLE: No, not at all.

Q: Edwin, *the Los Angeles Times* described you as "Major Hubble,
the titan astronomer." You're photographed in tweeds, holding or smoking
your pipe. Are a pipe and tweeds necessary to the image of
the twentieth-century astronomer?

EH: I wouldn't say that. I was a Rhodes scholar at Oxford at twenty-one.
I picked up Britishisms from the other chaps. They remain embedded. As for my
pipe, next to my wife, Grace, my pipe is my best companion.

Q: To what do you attribute your great success?

EH: My tweeds and my pipe. I do have a sense of humor, despite reports
to the contrary. The truth of the matter is that God has shone over my life. And
I've had my share of lucky breaks. My family wasn't particularly well off. They
couldn't afford the best in education or anything else. I've had many scholar-
ships and much assistance.

Q: Do you think there are special characteristics that astronomers need?

EH: Yes, I'd say so. One is memory. I have an excellent one. I also have
remarkable vision. This is a major asset in looking through the telescope and in
reading photographic plates. As far as my career, perhaps it just turned out that
I made the top score in the biggest game of the day.

Q: What would that be?

EH: Galaxies are moving farther and farther away from each other.

Q: Is this your most important discovery?

EH: Yes — the expansion of the universe.

EH: All work depends on previous research. I used recent findings such as categorizing stars based on their temperature and luminosity.

Q: What about Henrietta Leavitt? I met her tonight. Do her discoveries fit into your discoveries?

EH: Oh, yes, Henrietta Leavitt. Good work. She published findings on Cepheid variable stars in 1912, twenty years before I wrote my paper. Maybe she didn't get much credit for what she did. But that always happens with research. If you are not head of the project, your name may well go missing.

Q: How critical are the instruments you use?

EH: Absolutely critical. At Mt. Wilson in southern California we have a one hundred-inch telescope. The photographs from this telescope reveal stars very far away. By studying spectra in stars and galaxies, we know that most stars far away are moving even farther away.

Q: What is a spectra?

EH: Actually it's a spectrum, plural spectra. Spectra are wavelengths of electromagnetic radiation. These, of course, include visible light, but there are many spectra that we cannot see but give us information. Put most simply, lines of emission from stars may displace towards the red end of the spectrum. When that happens it is called redshift. This means the object is receding. Galaxies are moving away from each other.

Q: Can you describe what it is like to look through one of the most powerful telescopes today?

EH: The star systems are drifting through space like a swarm of bees

through the summer air. From our position somewhere within the system, we look out through a swarm of stars, past the borders, so distant that we do not see the individual stars of which they are composed. Some of the best looking today is from the Hubble Space Telescope. Too bad to lose that gem, and not just because it's named after me.

Q: I need your expertise. Just before these interviews began, there was a low, rather penetrating buzz, a bit like radio static. I was told this is a recording of the CMB, or the Cosmic Microwave Background. Can you explain this?

EH: Yes, sure. Be glad to. The Cosmic Microwave Background was discovered in 1965, nine years after my death. I wish I knew about it when I was doing my redshift calculations in the 1920s. The Cosmic Microwave Background is the remnant of the Big Bang, the first moments after the beginning of the universe. Matter cooling as the universe expanded. The temperature is under three Kelvin—very, very cold.

Q: Is it dark energy?

EH: No, it is not dark energy. To explain that would take more time than we have right now. The Cosmic Microwave Background helps us know when the Big Bang began. That is, what made possible the evolution of galaxies, stars, planets, and all life.

Q: Thank you, Edwin, and thanks for all the light you've shed on the universe.

EH: You're welcome.

RAINER MARIA RILKE

INTERVIEWER: Rainer Maria Rilke, that is a beautiful name.

RAINER MARIA RILKE: My birth name was René Maria Rilke. My mother fussed over me as a boy, dressing me in girls' clothes, refusing to cut my hair. My father shipped me off to military academy. I hated living with those young louts. I adopted Rainer instead of René.

Q: Do you resent your mother's smothering?

RMR: Now I can appreciate her gifts, her softness and gentleness shaped me.

Q: Why you think you were invited to this party and the performance? Your world and your interests are so different from the others. Do you feel awkward?

RMR: This slippage in time keeps me in a state of bewilderment. I am uncomfortable, but the company is interesting. Americans are straight-spoken. Every phrase flung out like a comet, streaking across the distance, escaping into the liquid heaven.

Q: The very liquid heaven...such a fine phrase, is that yours?

RMR: No, though I'd claim it. It's from René Descartes. Perhaps if I'd been born in Paris instead of Prague, I'd have hung on to René, not jettisoned it for Rainer. I think not, though; Rainer is a more beautiful sound. Sound is every-thing. I digress. I was invited—for the music. I want to hear *Makrokosmos III*. Let's hope this folderol will not detract from the music.

Q: You love this music composed one hundred years after your birth?

RMR: I do. I feel myself in Crumb's universe—it is not this world, our nar-rowly inscribed human globe. Crumb places me in the starry skies; I am a voy-ager in the universe.

Q: Your vision echoes Crumb's.

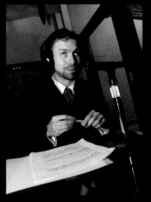

RMR: Crumb is really the one who matters here. I'd like to meet him.

Q: Why wasn't he invited?

RMR: He was, but he's seventy-five this year. Many celebrations world-wide, too busy. But I think he stayed away because he doesn't like public appearances. Who can blame him?

Q: Have you ever spoken with George Crumb?

RMR: No, but we've emailed. I wrote him a note of appreciation for quoting lines from my "Herbst," which means "Autumn" in English.

Q: Let's talk about the score and notes. What exactly did you write that Crumb used?

RMR: I can't answer that when you say *exactly*. You're American; few of this audience read or speak German. Neither am I German, but German is the language I usually write in.

Q: What words of yours did he use?

RMR: Crumb quotes the last six lines from a poem titled "Autumn," the moment of leaves falling. All else comes from this circumstance. The earth, the loneliness of humans on this sphere, that is enough.

Q: Would you read the last stanza of your poem in German and then translate?

RMR: I'll read and translate.

Und in den Nächten fällt die schwere Erde
aus allen Sternen in die Einsamkeit.
Wir alle fallen....
Und doch ist Einer, welcher dieses Fallen

unendlich sanft in seinen Händen hält.

There is in German a softening of the a, a faaaaaling that can never be heard in English...however, here you have it, my own translation.

And in the nights the heavy earth falls
out of all the stars into loneliness
We all are falling....

RAY EAMES

INTERVIEWER: Hello, Ray. Thanks for stopping by in the midst of your party.

RAY EAMES: Actually I'm happy to sit down for a few minutes. This cocktail party turned into a much bigger affair than I'd planned.

Q: But you entertain all the time, surely this isn't anything unusual.

RE: We're used to entertaining in our home. Here we have to imagine when people will arrive and how they will move through the space. And then it's always tricky to figure the flow of time. But it's wonderful to have the museum open its arms to us for the party and the performance. We surely couldn't have done this at Eames House.

Q: Let's turn to your films for a moment, and one film in particular—*Powers of Ten*.

RE: Yes, *Powers of Ten* is at the center of *A Very Liquid Heaven*. We're pleased because we've always felt that our film shows in the most concise way the far reaches of the universe and the minute world of quarks.

Q: I've been told there's something special about the physical placement of the film.

RE: They're going to project it on the ceiling. The audience will lie down on cushions and look up into the sky. We thought that would be a novel twist and, I must say, great fun.

Q: You designed the performance as well as having a hand in the upcoming exhibition. I love the way everything swirls around the music. Is this integration of outdoor performers, dance, and film with the music a radically new way of working for you and Charles?

RE: *Makrokosmos III* comes right out of earlier exhibitions. Ideas, not things, are what communicate. Our display reveals history, the course of individuals' lives,

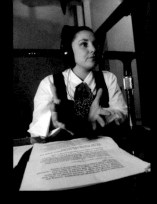

the symbolic as well as the rational, the fantastic as well as the functional.

Q: I've read some criticism for this approach, especially your exhibition *The World of Franklin and Jefferson* for the Bicentennial in 1976.

RE: Well, there are always critics, but that exhibition likewise was a success. In Paris fifty thousand people saw it.

Q: Abroad, yes, but here where viewers could see politics playing out in the street, critics pointed out that you glossed over the ugly in American history, heroicizing Jefferson, neglecting his views on slavery, the dual way he conducted his life. Then there was a complete absence of any Native American voice, showing North American Indians merely through the artifacts that white people collected.

RE: It was a severe oversight that we have greatly come to regret. We set out to be quite critical and hard about the main characters, but as we went on, we were so impressed by how much someone like James Madison was able to pull off time and again that we pretty much ended up being complete admirers.

Q: How do you think *Makrokosmos III* will be received?

RE: Some will complain that it is too much of an extravaganza, that it steals George Crumb's thunder. Ours is very different from any performance you have seen of Crumb's *Makrokosmos*. The performers and the dancers are not characters but simply humans who flow through time. Crumb's score itself is more a character than the characters are characters. Everything washes by propelled by the music.

Q: Your hallmark is simplicity. Certainly this is true in your own dress. You're famous for your pinafores. Tell me what you're wearing.

RE: I'm wearing the same thing I wear every day, in or out of the office. I am wearing a pinafore over a blouse with a small collar with a tie at the neck.

Q: Is that a bow in your hair?

RE: Oh, yes. I always wear a bow in my hair.

Q: I hope you won't be offended, but that's very much a little girl image. You've dressed this way since you met Charles. A style perhaps for a twenty-year-old. Can you see yourself in pinafores and bows when you're sixty?

RE: Yes, I can. I am not trying to belie my age. Simplicity, not stylishness. The pinafore is a serviceable garment. It's feminine and has a proud history in the world of work. I refuse to dress in a masculine mode. I'm delighted to be a woman. I don't like being called "a delicious dumpling in a doll's dress," as one TV commentator called me, but trousers are definitely out for me.

Q: Ray, again, thanks a lot for coming by

HENRIETTA LEAVITT

INTERVIEWER: Miss Leavitt, thank you for joining us this evening.

no response

Q: Miss Leavitt, thank you for joining us this evening.

HENRIETTA LEAVITT: You're welcome.

Q: Can you hear me clearly?

no response

Q: Can you hear me, Henrietta?

HL: Please speak more slowly.

Q: You can turn the volume up on your headset. Do you see the dial?

pause while she fiddles with the dial.

HL: I have been hard of hearing ever since I had measles at age six.

Q: The music of the stars is, of course, a well known phrase.
Do you think there is a connection between your love of music and your love
of astronomy?

HL: Perhaps, but I don't know what it would be. I like studying the stars
because they are so silent and so far away. Pascal said: "The eternal silence of infi-
nite space terrifies me." I like the boundlessness, the impossibility of fathoming
silence and space. But terrifying is not the right word for me. Comfort is closer
to my world, since I dwell to a large extent in eternal silence.

Q: I understand that you work with telescopes and I'm wondering how you
do this, since you work days.

HL: I don't observe. I work on photographic plates, but I don't use the
telescope.

Q: What exactly do you do?

HL: I examine photographs on glass plates and record this information on charts in my notebooks. I look at similarities and differences in plates taken over a long period of time.

Q: Your name is linked to Cepheid variable stars. What is special about them?

HL: Would you repeat your question?

Q: Cepheid variable stars. What intrigues you about them?

HL: The luminosity of Cepheid variable stars changes in a regular cycle. They are bright; then they become dimmer and then grow brighter again. The cycle runs around fifty days.

Q: How strange. You mean stars shrink and expand all the time?

HL: Spend all the time?

Q: Shrink and *expand* all the time?

HL: Not all stars, not all the time. Only variable stars.

Q: You wrote a paper titled "Periods of 25 Variable Stars in the Small Magellanic Cloud"—is that research you just published?

HL: Dr. Pickering published that paper.

Q: His name appears on it but we know it's your findings. Does that rankle you?

HL: Wrinkle me?

Q: Does that rankle, anger, you?

HL: Anger me? Why should it? We all work as a team. Dr. Pickering does not treat us like servants.

Q: Let's go back to the variable stars.

HL: The Cepheid stars I worked on are all about the same distance from the Earth. Because of this, it is relatively easy to figure out their brightnesses, and consequently their luminosities or absolute magnitudes.

Q: Is this somehow related to Edwin Hubble's discoveries?

HL: Yes. He used Cepheid variable calculations to measure distances to galaxies. This helped him realize that the universe is expanding.

Q: Let me shift the conversation to this party. Why do you think the Cameses invited you tonight? Did you know them before this evening?

HL: No, not at all. Mrs. Eames called me. She said that Hubble would be here. I didn't know who he was either, but I looked him up on the internet. Mrs. Eames thought I'd like to hear George Crumb's music because of its allusions to the universe. She sent a player and a small reflective disk that says "Music for a Summer Evening (Makrokosmos III)." I inserted it in the player and the music came out. I have played it five hundred times.

Q: Thank you for sharing your discoveries about the universe with us.

HL: Yes, I am caring about the universe. Thank you for inviting me.

CHARLES EAMES

Q: In your 1972 interview with Madame L. Amic for the exhibition *What is Design?* she asked what are the boundaries of design? Do you remember your answer?

CE: I replied: "What are the boundaries of problems?"

Q: And then, "Does the creation of design admit constraint?"

CE: Design depends largely on constraints.

Q: What constraints?

CE: The sum of all constraints.

Q: Does design obey laws?

CE: Aren't constraints enough?

Q: Eames design, architecture, and films are as fresh tonight as when you and Ray produced them thirty to fifty years ago. What is your favorite?

CE: *Powers of Ten*.

Q: Why?

CE: It compresses enormous shifts of distance in logical way. I think of Eliel Saarinen's observation that in looking at a project you need to look at the next smaller or larger thing.

Q: You must be pleased that *Powers of Ten* is central to *A Very Liquid Heaven*, the exhibition that will open in this

space a week after the performances.

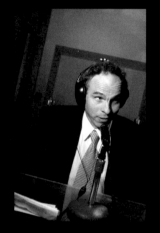

CE: It's interesting that *Powers of Ten*, finished in 1978, is still accurate, though our knowledge of the greatest and the smallest in the universe has changed.

Q: What brought you to this project?

CE: A preoccupation with structure which comes from looking at all problems as architectural ones. I was intrigued to design a party around performance of a musical composition and enfold them in ways that reverberate with the architecture.

Q: Speaking of architecture, what do you think of Antoine Predock's Tang Teaching Museum?

CE: Movement through space determines the shape and form of the building. The light is excellent and the building hugs the landscape. I am comfortable in the space, a test of good architecture. It's not the Kimball Art Museum, but there are moments that make me think of Louis Kahn.

Q: In one of your films you joined moving water with J.S. Bach's *Goldberg Variations*. Do you think that's related to George Crumb's quotations of a Bach fugue from *The Well-Tempered Clavier* in *Makrokosmos III*?

CE: No, I'd say you are stretching it, though I do enjoy Crumb's quotes and references not only to Bach but also Bartók and Debussy.

Q: I can see you'll have to leave soon to usher your guests into the performance, so one last question. You often speak about Ray's input. What do you most rely on her for?

CE: She has a very good sense of what gives an idea, or form, or piece of sculpture its character, of how its relationships are formed. She can see when

there is a wrong mix of ideas or materials, where the division between two ideas isn't clear. She trained as a painter, studied with Hans Hofmann. She has an almost magical sense of color. I trained as an architect. Our education and outlook match perfectly. You'll excuse me now; I need to usher our guests into the performance.

Q: Thanks for stopping by.

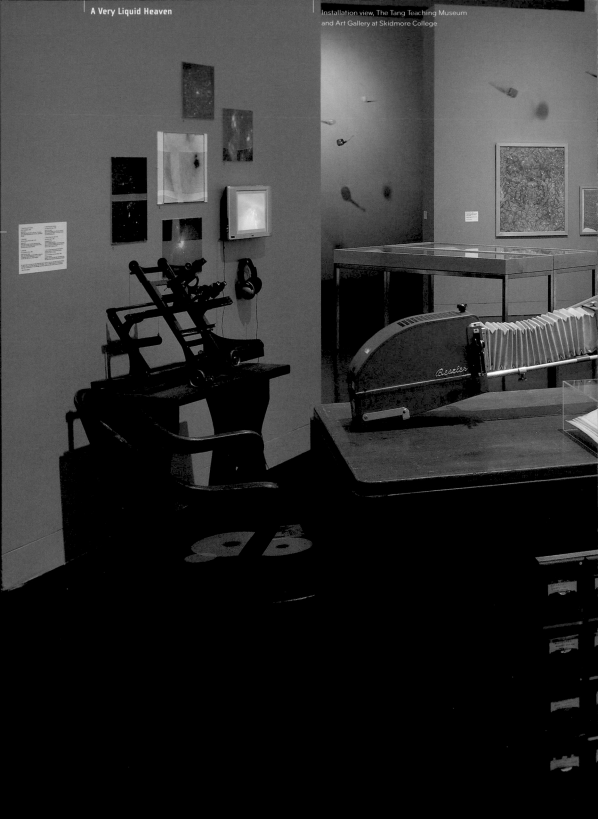

Installation view, The Tang Teaching Museum
and Art Gallery at Skidmore College

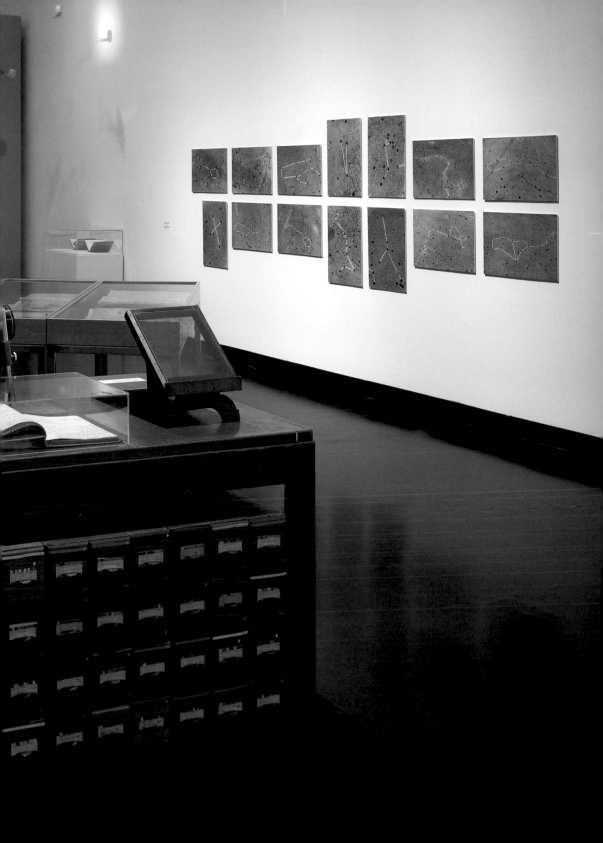

TWO VIEWS
OF THE UNIVERSE

MARGARET J. GELLER AND SCOTT J. KENYON

SENIOR SCIENTISTS, SMITHSONIAN ASTROPHYSICAL OBSERVATORY

WE HAVE KNOWN EACH OTHER FOR TWENTY-ONE YEARS. Throughout our friendship and our marriage, we have shared many things, including our perceptions of the universe. Both of us have been amazed that with essentially the same formal educational background our views could be so different. The differences enrich our experiences together, but until now we never thought about the reasons for our perspectives.

MARGARET I grew up in suburban New Jersey where only the brightest stars were visible in a sky lit by the city. Unlike many people who become astronomers, I was not interested in the stars at all as a child. My parents encouraged my curiosity about the world around me, and my father, who was a crystallographer, spurred my interest in science. He bought me a microscope and showed me the infinite world of six-pointed snowflake designs. Even as a child I absorbed the connection between geometry and nature. I remember that when my parents took me to the famous art museums in New York, I was always looking for patterns. I have kept doing that all my life, around me and in the universe.

SCOTT I grew up in Arizona when Phoenix was a small city and the night sky looked three-dimensional. Outside the city, I felt I could touch the stars. For my twelfth birthday, I wanted a small telescope. Surprised, my parents obliged, thinking that this interest would soon end like many others. But when I saw the rings of Saturn, the moons of Jupiter, and the craters on the Moon, I was hooked forever. I remember my fascination with the perfect circles of the lunar craters and the delicate, almost unreal beauty of Saturn's rings. Although I dreamed of traveling to distant worlds, I never thought I could make a living studying objects in the sky.

MARGARET Big, grand ideas have always fascinated me. Sometimes they scare me, and at others they make me feel important just to be able to get my mind around them. I first learned about the Big Bang model of the universe when I was an undergraduate at Berkeley in the famous 1960s. I thought it was amazing that people could think they understood the universe when they had observed so little of it. I was fortunate that I went to graduate school at a time when people were first building the machines of modern cosmology,

machines that today take us to the limits of the visible universe. During my professional life-time it became possible for the first time to know how the universe looks and how it came to be as we see it today. When I think about astronomy I think first of galaxies like our own Milky Way, vast systems of stars, gas, and mysterious dark matter, flowing along with the expansion of an even vaster universe.

SCOTT My career began with the space program and with stories like *Star Trek* and *Star Wars*. I remember watching the Gemini splashdowns, and making my own splashdowns with plastic models in my backyard swimming pool. I still enjoy reading stories about other worlds and imaginary civilizations. As a scientist, it is hard to have a clear mental picture of an abstract idea or a dry set of equations. The mental voyages of science fiction give me a more human picture of the galaxy that helps me think about scientific problems. I start with small building blocks, put a tentative picture together, and then look to see how other pieces might fit into the picture.

When we look at the sky, everything we see is light from stars. Even the planets simply reflect light from the sun. In daytime, it is reassuring to see the bright disk of the sun. At night, you can often see at least one planet. With a pair of binoculars or a small spotting scope, you can see the disks of the largest planets and the different colors of the stars. Seeing these with a limited aid is a direct, human connection to our planetary system and the nearest regions of the galaxy.

MARGARET Only three galaxies outside the Milky Way are visible at all with the naked eye. Only the largest of these, called Andromeda, is visible from the northern hemisphere and it is hardly an impressive sight. It looks like a cotton puffball on the sky. Even looking through a small telescope, galaxies are not impressive. They appear as dull gray fuzzy blobs of light because our eyes refresh every twentieth of a second. The human exposure time just isn't long enough to record these "island universes" in their grandeur. Photographs are the secret to unveiling the beauty of galaxies. The images I carry in my mind are not the disappointing fuzzy blobs, but the spectacular spirals of coffee table books and websites.

Even though I work on these objects every day, my connection to them is really abstract. I think of them as filling a computer screen on my desk or as images on a sheet of paper. Of course even the largest posters or screens cannot begin to do justice to the daunting size of these objects. They extend for a hundred thousand billion miles and contain many billions of stars like the sun. There is really no way for me to imagine this scale. I just draw them on a piece of paper and I am somehow satisfied.

SCOTT In science fiction, the distances between stars are not as daunting as they really are. Traveling from one star to the next is as simple as flying from New York to Los Angeles. It is misleading, but I like it. I know, though, that distances between stars are vast. If people on Earth were distributed like stars in the Milky Way, there would be only one person per continent!

MARGARET For me the universe is an abstract, lonely place. I like thinking about it because the objects are beautiful and because the story of the way they form and evolve is part of the story of the origin of life on Earth. For understanding the universe is the story of tiny creatures with minds that can reach for several billion trillion miles to the edge of the visible universe. Exploration and the desire to know make human beings special.

SCOTT I study our origins in the formation and evolution of stars and planets in our galaxy. Although we can see to the edge of the universe, only a handful of us have visited another world. When astronauts explored the Moon, images of their footprints in lunar dust and a pale blue dot suspended in cold, empty space helped to define our place in the universe. The picture of the Earth from the Moon made many people realize that our world is a complex, fragile system, and shows how our explorations change our perception of ourselves.

When the first images from the Mars rovers appeared on the web, millions of people rushed to see Mars up close. NASA's web server nearly seized up with all of the hits. For days, scientists and lay people were enthralled by the varied terrain and excited by the possibility that the next image might show evidence

of water—or maybe life. For scientists, the images are also frustrating. We can only observe, not interact with or manipulate, the planet. To conduct experiments, we turn to the computer.

Computers are the laboratories where we experiment with our mental picture of the universe. Our effort is similar to thinking about a computerized kitchen that simulates baking cookies. We put together the ingredients for the cookies, vary the proportions of each ingredient, and envision how the size and temperature of the oven changes how the ingredients cook. Then, we try to think of a way to measure how each recipe tastes.

I use a computer to simulate the formation of Earth-like planets. When a star forms, it is surrounded by a large disk of gas and dust. The dust particles in the disk collide and, like the dust bunnies under a bed, grow into larger objects. Ten million or more years of collisions yield an Earth-like planet. For my Earth recipe, I imagine the right ingredients and put them together in a computer.

It is a challenge to show the results of the simulations. When a planet forms, the disk dims and then brightens. Bright rings form and disappear. The planets move inward and outward through the disk. To see how each outcome depends on the ingredients of our recipe, we make a movie of each simulation. In a few minutes, we can visualize millions of years in the life of a planetary system. Right now, we do not have enough observations to test our movie very well. But in ten or twenty years, images from telescopes like OWL, the Overwhelmingly Large Telescope, will test our recipe for planet formation.

MARGARET When I was an undergraduate, all students had to have a slide rule. There was no such thing as a hand-held calculator. Our "big computers" had much less power that a standard laptop today. Few of us dreamed that simulations like the ones Scott does would provide detailed pictures of objects in the universe and their history.

Today, simulations show us how the large patterns I discovered in the universe form and evolve. In the mid 1980s my colleagues and I mapped the way galaxies like the Milky Way are distributed in the universe around us. It was a thrilling surprise to see that these objects

mark the largest patterns in nature. There are vast empty regions hundreds of millions of light years across (a light year is six trillion miles) surrounded by thin sheets containing thousands of galaxies. The pattern is like soap bubbles in the sink on a grand scale. Identifying the pattern with everyday experience was part of making it mine. The feeling is like identifying a painting with a personal experience or familiar place. There is a richness of connection.

The comparison of models with observations is a challenge. Human beings are wired up to recognize patterns even when there are none. We see animals and human forms in clouds and rock formations. We identify aspects of images as important when they lock into our personal experience. Scientists make the same connections and it is often hard for them to be objective in making connections.

When I mapped the nearby universe around the Milky Way, the differences between our map and the then-current computer models impressed me. People who made the models emphasized the similarities between the models and the observations. In a sense, both perceptions had merit. In the last twenty years, both the simulations and the observations have yielded more and more extensive and striking pictures of the grander and grander universe around us. The models are a better and better match to the data as we understand more and more. Our ability to picture the universe is a measure of our understanding.

MARGARET AND SCOTT We are lucky to take part in the exploration of the universe when telescopes provide spectacularly detailed images of proto-planetary disks and of distant young galaxies in the process of formation and when computers have become earthbound laboratories for explaining the pictures we see and will be able to see with the very large telescopes of the future. One of us builds the universe from the bottom up, the other sees it from the top down. We meet with the equipment we use and with the fascination we share.

DEL DRAGO

FIGVRA III.

VERSO DOVE

DONDE

PARTE VERSO
IL POLO

DONDE

VERSO DOVE

3 3 3 3 3 3 3 3 3 3 3 3

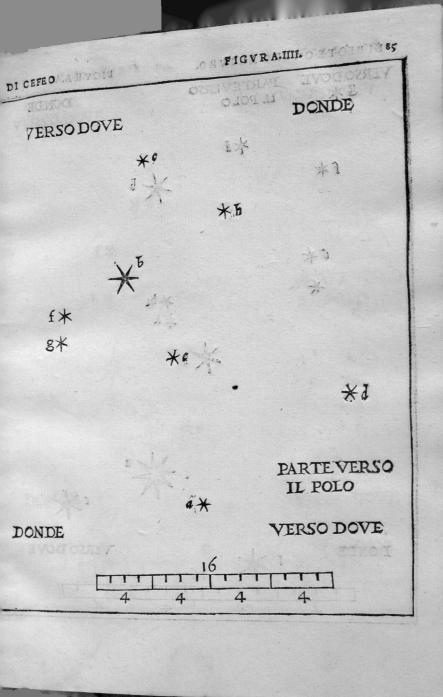

VERSO DOVE PARTE VERSO
IL POLO
DONDE

DONDE

VERSO DOVE

PARTE VERSO
IL POLO

DONDE

VERSO DOVE

16

4 4 4 4

PLANAS REDACTI PARS I.

1730 tam Arithmeticè quàm Geometricè exhibentur

Nat: Curiosorum, nec non Societatis Regiæ Borussicæ Socio

ÆS. MAJ. GEOGR. Norimbergæ.

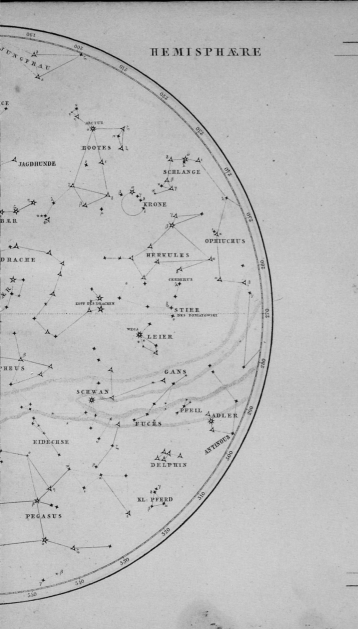

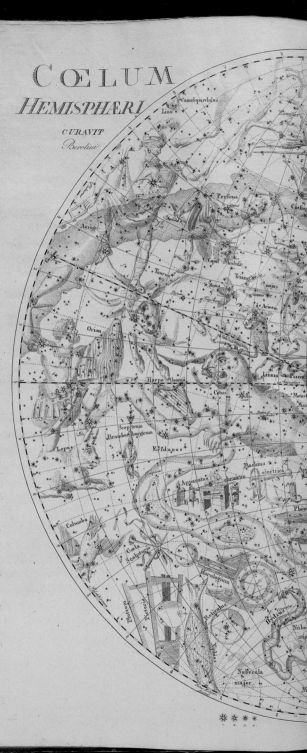

Uranographia Tab. I.

STELLATUM.
...um ARIETIS.

J. E. BODE.
1801.

Image size, 21 1/4 x 23 3/4 inches
Dudley Observatory, Special Collections, Schaffer Library, Union College,
Schenectady, New York

Fig II.

Cum orbitarum centra pro Planetis primarijs non longe à Solis centro ceu nodo communi distent: sol autem, secundum Tychonem, singulis annis periodum suam decurrat, hinc orbitas illorum ut et centra simul circumferri. ita tamen ut Apsidum lineæ A B gerat, fig. I. incidetat, annuo spatio quo ad sensum inaqualibus procedant necesse est, sicque ob perpetuò orbitarum luxationem simultaneità et inperturbatam in hac motu Planetæ lineas curvas in cælo desinant. quod melius per fig. II. hic demonstratum dabimus: Sic igitur circulis intermediis in 15. partes æquales pro 15. quadrisijs optimatibus fiatsij per annis exhibendis se usijs, orbitæ Solis extra hanc alia ex superioribus Jovis v. g. In has si primo ponamus Jovem col. A. in lineæ Apsidum A B, et simul in conjunctione cum Sole o è Terra T spectari. orbita Jovis tunc erit in o.o.s.o. jàm verò is Sol ad o. ad I. intra 4 Septimanæ feratur, orbita Jovis simul promota ab A ad 1.1.1.1. perstabit Jupiter interim quoque motu suo à puncto a, ad b. usqȝ motu hic ab A ad b Desinibet portione alicuius lineæ curvæ jam à porro Sol in orbita sua per successivam ftationem quadrisij optimatale ab 1. ad 2. moveatur, orbita Jovir in 2.2.2.2. excistet, Jove interim per tantum iterùm spatium quando erat primum ab a. ad b. ita ut a. sit duplum lineæ a b. lata. alia continuata portio b.c. et, sic ulterius procedendo, tota linea quasi a. toe Jovas periculi numerando dabitur.

BILLY RENKL

Proposal for a beaded and quilted silk to be made into a coat for Galileo, 2002

Framed mixed media drawing, 40 x 32 inches
Framed quilted French silk damask, c. 1740, 20 1/2 x 14 1/2 inches
Courtesy of the artist, Clarksville, Tennessee

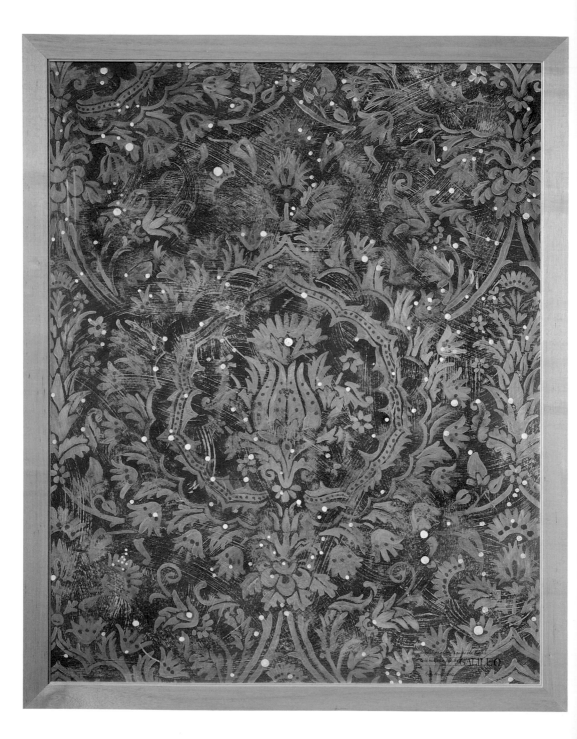

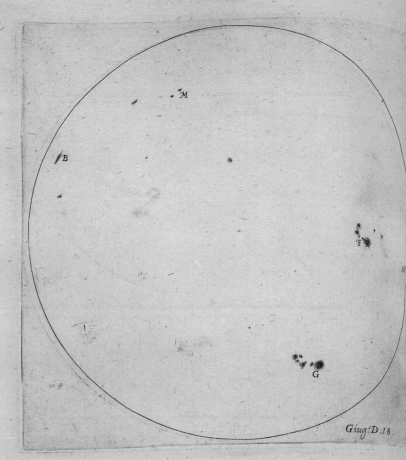

Giug.D.18.

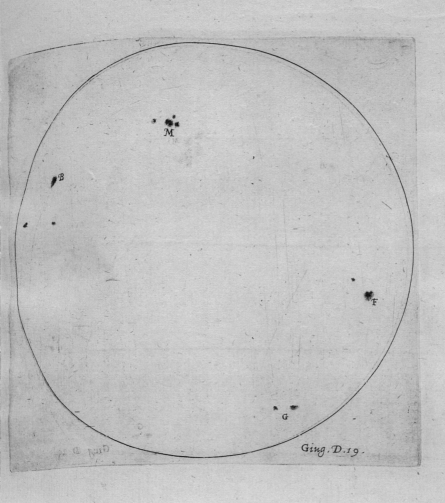

Ging. D.19.

in foreground:

KIKI SMITH
Nuit, 1993

Anodized aluminum, bronze, mohair
Dimensions variable
Williams College Museum of Art, Museum purchase,
Kathryn Hurd Fund, 94.13

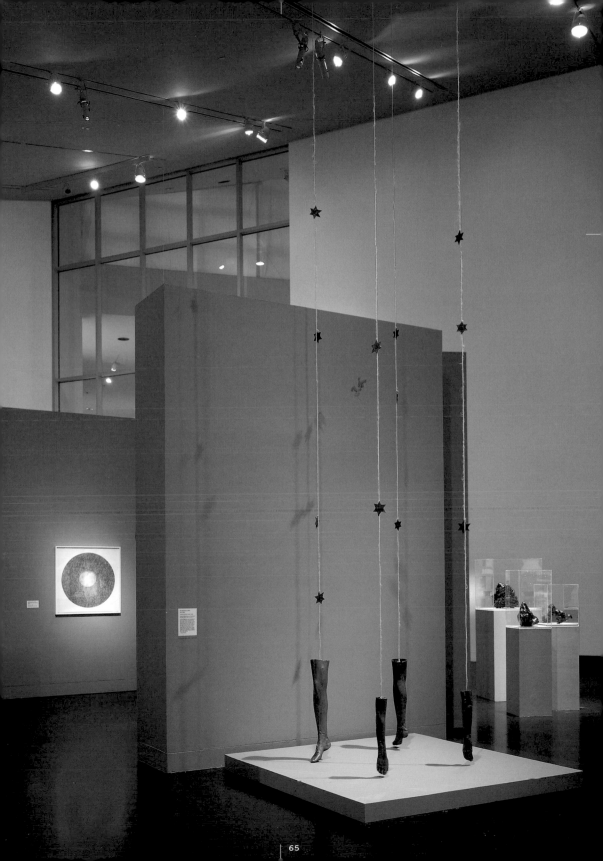

A VERY LIQUID HEAVEN

MATTHEW WILSON

SCIENTIFIC DISCOVERY HAS PUT TO REST a lot of early beliefs about the heavens. It has not, however, robbed these beliefs of their seductive, anthropomorphic origins and the power such ideas hold. While the gods and goddesses who once were the explanation for the movement of the stars have long since been dethroned by gravity and inertia, depictions of these figures have not faded from memory. Within *A Very Liquid Heaven*, a divine vocabulary applied to current scientific knowledge elevates the heavens, whatever their design, to something more than an equation.

Johannes Bayer's *Uranometria* is a catalogue of constellations with meticulous measurements placing them *in situ* among the heavens. An exacting scientific survey, yes, but the title page is fantasy: it depicts Diana, Apollo, and Hercules holding up the heavens. These characters had long since been relegated to myth by the time *Uranometria* was published, yet Bayer nevertheless included them. They function as more than decoration; Bayer's conscious inclusion of myth within a scientific text suggests that he was trying to strike an artistic balance between the fantastic and the clinical. To prevent the sky from being measured into aesthetic oblivion, he presents what he knows is fact and illuminates it with the ethereal.

Kiki Smith's work often focuses on female figures from fairy tales, the Bible, and myth. Her piece *Nuit* captures Nut, the Egyptian goddess of the sky, as her hands and feet stretch to touch Earth. The stars that hang above her limbs give Nut enormous scale; we can imagine the arch of her back extending far

above the surface of the Earth. Here, the use of a goddess feminizes the sky itself. Of course Smith is aware of the scientific explanations of the stars, but *Nuit* uses a mythological figure to tailor the very idea of the heavens to Smith's own feminism. Nut, among her coterie of stars, gives the movement of the universe a significance it would not have if it were left entirely to Galileo.

The layout of the exhibition mirrors, in a way, this augmentation of science with art. The first piece encountered is a wall of photographs of the universe. This wall acts as a gateway to the exhibit, which includes both scientific surveys, including *Uranometria*, and artistic interpretations of the heavens. While the older documents are clustered in one section, the artworks in the show cohabitate with a modern orrery and real meteorites. The show orbits Russell Crotty's suspended globe with a pen-and-ink drawing of the night sky on it, taken star-for-star from the artist's own observations. The show achieves an almost perfect balance of art and science.

The artists (and the scientists) featured in *A Very Liquid Heaven* won't let the heavens be reduced purely to science. This is not, I think, intended to be a criticism of science's explanations, but rather an examination of the human refusal to accept something as vast and beautiful as the sky simply as a function of physics. The truths of science are recognized for their own value, but the artistic embellishment of these truths is celebrated as well. Science, charging forward, has not left creativity behind as a relic. It couldn't. It wouldn't be enough on its own.

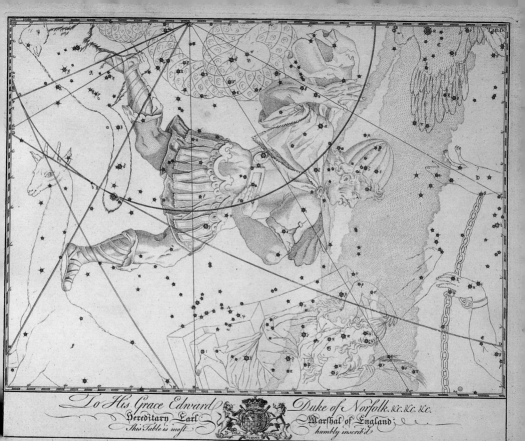

Pl. IV.

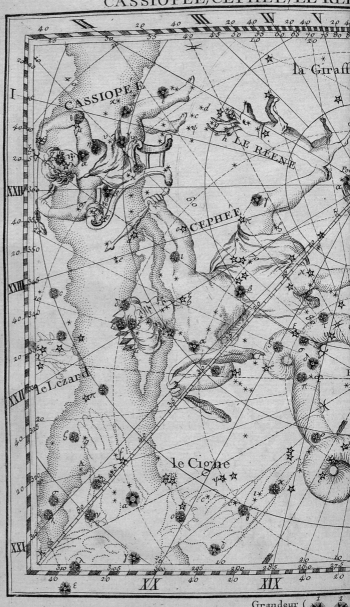

VII 20 40 VIII 20 40 IX 20 40 X

la G.de Ourse

XI

XII

LA P.te OURSE

XIII

LE
DRAGON

XIV

le Bouvier

XV

Hercule

XVII 40 20 XVI 40 20

5 * 6 * nebu. {

Image size, 17 1/2 x 22 3/4 inches
Collection of Jay M. Pasachoff, Williamstown, Massachusetts

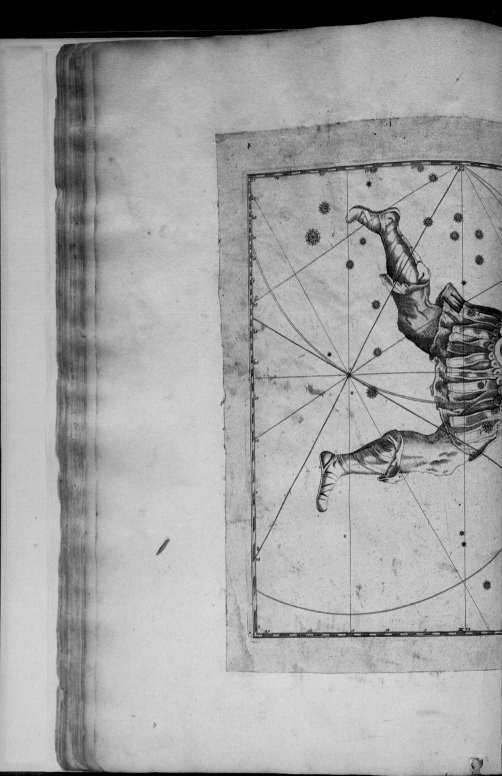

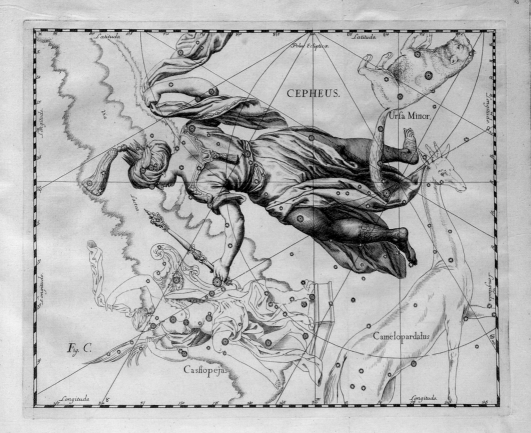

CEPHEUS.

Ursa Minor.

Polus Eclipticae

Camelopardalus.

Cassiopeja.

Fig. C.

SEBASTIÁN ROMO
Constelaciones series, 1997

14 C-prints mounted on sintra
23 x 16 inches each
Collection of William & Anne Palmer, New York
Courtesy of Greenberg Van Doren Gallery, New York

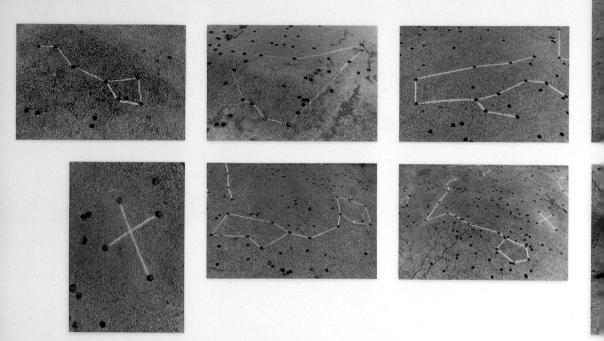

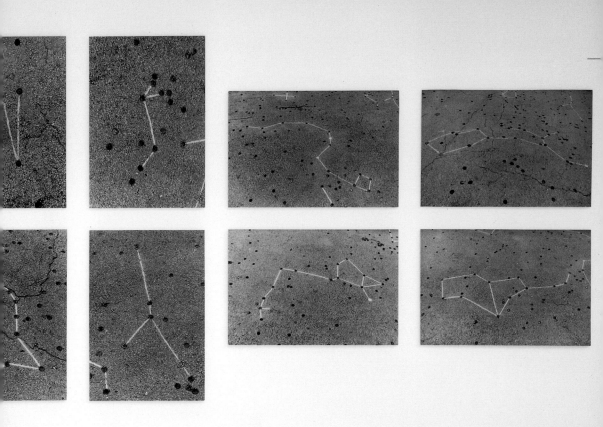

Farquhar Transparent Globe, c. 1960

36 inch diameter
Dudley Observatory, Union College, Schenectady, New York

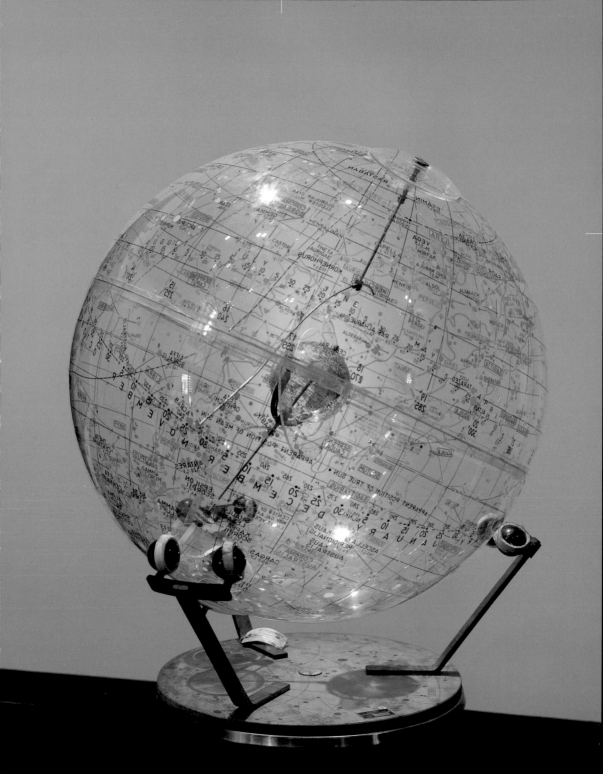

NGC 6543 PLANETARY NEBU
LA IN DRACO. . . . STAR LIKE
IN SMALL INSRUMENTS
A PALE BLUE - GREEN GLO
W. . . . WITH HIGH MAGNIFICA
TIONS IT BECOME A DIS
K. . . . LARGE SCOPES
SHOW DARK AND
LIGHT AREAS. . . SO
ME SEE IT AS A SKULL
LIKE OBJECT WITH
GHOSTLY MELTING
FEATURES. . . . AS IN MAN
Y PLANETARY NEBU
LAE IT SEEMS TO CRA
WL ABOUT THE DIFFUSE DISK.

NGC 6853 · M27 THE DUMBBELL NEBULA IN VULPECULA · PLA
TARY NEBULA · A FUZZY PATCH OF GREY LIGHT IN BINOCULARS · LOCATE
N A RICH SECTION OF THE SUMMER MILKY WAY IT'S A NATURAL HOT ITEM
— SUMMER STAR PARTIES. THROUGH MODEST INSTRUMENTS THE DUMBBELL
HOUR GLASS SHAPE IS READILY APPARENT MUCH MORE DEFINED THAN
HE CRAB NEBULA WHICH APPEARS LIKE A DIFFUSE PIECE OF FAINT
TEEL WOOL FLOATING IN THE ABYSS OF SPACE · FROM THE SOLSTICE PEAK
SERVATORY WHICH IS SEMI LIGHT POLLUTIED THE DUMBBELL IS ONE OF
E LOGICAL TARGETS ON A MOONLESS NIGHT AND A FUN OBJECT AS A
EAK FROM THE RIGOROUS PLANETARY OBSERVATIONS THAT ARE THE
HARGE OF THIS PARTICULAR FACILITY. THROUGH THE 10"F8 INSTRUMENT
HE DUMBBELL SHAPE IS READILY VISIBLE EVEN TO THE UNTRAINED EYE ·
NDER MEDIUM MAGNIFICATION ON A STEADY NIGHT THE NEBULA SEIEMS
JSPENDED · A FLOATING EFFECT · IN FRONT OF FIELD STARS · ALTHOUGH
HE SHAPE IS EASY TO SEE SOME MORE SUBTLE FEATURES REQUIRE
ARGE INSTRUMENTS AT A DARK LOCALE. ONCE THROUGH A
1"TELESCOPE AT A FAIRLY DARK SITE THE SHELL SURROUNDIN
THE HOURGLASS SHAPE WAS QUITE APPARENT. ONE OF THE
EAREST PLANETARIES LURKING ABOUT 900 LIGHT YEARS
WAY FROM OUR SOLAR SYSTEM. THE CENTRAL STAR IS A HOT
LUISH SUB-DWARF THIS STAR ILLUMINATES THE GASEOUS
HELL AROUND IT. THE NEBULA IS FIGURED TO BE
XPANDING AT ABOUT 17 MILES A SECOND. I FIRST GLIMPES
THIS NEBULA THROUGH A HOME MADE 12½" REFLECTOR
T AGE 12 AT A STAR PARTY HELD AT A DARK MONESTARY
TOP A ROLLING HILL IN NORTHERN CALIFORNIA. QUIET EXCL
MATIONS OF AWE COULD BE HEARD AS OBSERVERS LINED UP FOR
LOOK. YEARS LATER PICKING UP THE ASTRONOMY BUG AND AQU
NG A DECENT COMMERCIAL INSTRUMENT I AGAIN WAS RECIEVING
ETINAL STIMULATION FROM THE DUMBELL. EMPLOYING
ETTING CIRCLES ON A WARM AUGUST EVENING THERE IT WAS
RIFTING INTO THE FIELD THE WONDERFUL FUZZY DOUBLE PATCHES
ITH REQUISITE CRAWLING EDGES TYPICAL OF FAINTER NEBULAE.
T'S FUNNY HOW SOME DEEP SKY OBJECTS BECOME EMBLEMA
C IN THE BRAINS SHOOTING GALLERY... THE RING NEBULA... THE
WAN ETC... ETC... THE GREAT THING IS OBSERVING THESE THROUGH
OTS OF DIFFERENT SCOPES UNDER VARYING CONDITIONS AND DRAWING THEM.
N REGARDS TO THE DUMBELL I THINK ADMIRAL SMYTH THE
NTHUSIASTIC OBSERVER FROM THE LAST CENTURY PUT IT WELL
ESCRIBING IT AS A "MAGNIFICENT AND SINGULAR OBJ
CT.... SITUATED IN A CROWDED VICINITY WHERE FIELD
FTER FIELD IS VERY RICH.... TRULY ONE OF THOS
SPLENDID ENIGMAS WHICH.... ACCORDING RICCIOLU
ARE PROPOSED BY GOD BUT NEVER TO BE SUBJECT TO HU
AN SOLUTION." THE DUMBBELL NEBULA NGC 6853 MESSIER
7 RIGHT ASCENTION 19H 57M DECLINATION 22° 35. ···

RC PRINCIPLE INVESTIGATOR SOLSTICE PEAK OBSERVATORY

THE WORK OF A WOMAN:

PAY CAREFUL ATTENTION,
FILTER DATA,
SORT TO CONCLUSIONS

THE GATEWAY TO *A VERY LIQUID HEAVEN* invites you to imagine Henrietta Swan Leavitt at work. "Henrietta's Stars," a wall of 105 glass plate negatives from the Harvard College Observatory (HCO), stretches across twelve feet of the large opening to the Wachenheim Gallery. Though it serves as a physical boundary, it is not truly a wall but a transparent, erect grid. From the atrium you see through to Henrietta's desk and *A Very Liquid Heaven* beyond. Within the exhibition you look through, up to the sky or into activity in the atrium.

Henrietta Leavitt worked at the HCO in the early twentieth century. She was a highly trained technician who made an important discovery through years of carefully observing and recording. She is essential both in the performance accompanying George Crumb's *Music for a Summer Evening (Makrokosmos III)* and in the exhibition. She is like a telescope, she admits light and magnifies observations.

Her name is linked forever to a type of star, a Cepheid variable star. Such stars vary in brightness over a set period of time. Typically bright in the beginning of their cycle, they diminish slowly in brightness, remaining diminished for most of the cycle, only to rapidly increase in brightness for a brief time at the cycle's end. Astronomers had established this pattern well before Henrietta did her work. Leavitt's contribution was her realization that period is linked to luminosity; that is, the longer the star takes to complete its cycle, the brighter the star—"a remarkable relation between the brightness of these variables and the length of their periods will be noticed."[1]

This is how she phrased it in a paper titled "Periods of 25 Variable Stars in the Small Magellanic Cloud" published in 1912 by the HCO. Knowing the periods of the Cepheid variables makes it possible to measure the distance of these stars from the earth. Known as standard candles, Cepheid variables measure the distance to stars beyond our galaxy. Leavitt's discovery vastly increased astronomers' ability to measure distances, well beyond the relatively close ones obtainable by trigonometric parallax and the inverse square law.

The light bulb is an often used metaphor for a Cepheid variable. In the exhibition-related performance of Crumb's *Makrokosmos III*, dangling light bulbs

provided illumination but also referred to this frequent symbol for Cepheid variables. The light bulb in its human-scaled, manufactured objectness connects brightness, variation and distance—a relationship not easy to understand when looking at the stars. Dennis Richard Danielson gives one version of this metaphor of light bulbs being stars:

> To put this in familiar terms, suppose we are sitting at one end of a darkened stadium and have to answer some skill-testing questions about how far away certain flashing light bulbs are from us. We are not told the wattage of these bulbs; but we are told that the higher the wattage of the bulb, the more slowly it will flash. Accordingly, if we see two bulbs A and B, that have the same brightness (= apparent luminosity) and they are flashing at the same rate, we will know that A and B are equidistant from us. But if we see two other bulbs, C and D, apparently of the same brightness, but C is flashing twice as fast as D, then we will know that D is actually much farther from us than C is, for there's no other way to explain why a higher wattage bulb would appear only as bright as one that is in fact less luminous.[2]

At the turn of the twentieth century, finding Cepheid variables was central to astronomical research at HCO. In 1895, thirty-three Cepheid variables were listed; Henrietta Leavitt added over 2,400 by 1921, the year of her death. Under Edward C. Pickering, director of HCO from 1880 to 1919, visual observation was outpaced by telescopic photography. Henrietta Leavitt and many others analyzed and compared consecutively photographed areas of the sky. Their findings bolstered Pickering's goals of determining the brightness of stars in order to compute distance.

Henrietta Leavitt's name did not appear on "Periods of 25 Variable Stars in the Small Magellanic Cloud;" Pickering's did. Yet it is her conclusions on Cepheid variables that are essential not only for Pickering's work, but for all that followed, especially Edwin Hubble's theory of the expanding universe.

Hers was a day job. She recorded stars ballooning and shrinking in well

	MC15979	MC10223 BD37686			Sum Mean mean	Blue Sum	MC15979 Yellow	B-Y
+7° 2703	15	· · ·			15 150	0.00	0.0	0.0
+7° 2698					15 150	1.50	0.5	+1.0
2692	1	1 3 5			10 25	1.75	0.5	+1.3
2696	4	2 1 1			8 20	1.95	0.7	+1.3
+6° 2797	*	-1 0 0			-1 -08	1.87	1.5	+0.4

C.I. – +6° 2797

	Blue	Yellow	Blue – Yellow		
+7° 2698	0.00	0.00	0.00	red star	+0.63
2692	0.25	0.00	0.25	very red star	+0.88
2696	0.45	0.20	0.25		+0.88
+6° 2797	0.37	1.00	-0.63	white star	0.00

If we assume that the white star +6° 2797 is of Class A, the star +7° 2692 would have a color index of 0.88, or 0.9. On page 51 comparisons are made with the prismatic comparisons and with diffraction wings of BD+7° 2690 and other bright stars whose spectra are known. Comparisons are difficult as the stars are widely scattered, but when placed in order, the differences between the scales derived for the blue plate MC 10223 and the yellow plate MC 15979 gave color indices which were the same for prismatic comparisons and for diffraction wings, namely, C.I. for 2690 = 0.40 and for 2692, = 0.80.

See summary page 58

Friday, December 27, 1918

0 1 2 2 3 3 b R S Sculptoris.

Examination of Plates at the
request of Miss ~~Edith~~ Mabel Gill
to decide whether the star varies
and its identification.

According to the Geschichte und
des Lichtwichsels (Astron. Gesell.) Vol. 1
a combination of Observations by Innes
on plates taken at the Cape and
of photometric Observations gives some
magnitudes on a uniform system
with a variation from 9.8 to < 11
between 1893 and 1902. Innes found
~~changes on~~ a star in this position 8 plates taken between
Dec. 18, 1897 to May 16, 1898.

~~It precedes~~ a 10th magnitude 58ˢ, north 2ʹ

 " 9.6 " " 25 south 7

 follows 10 " " 20 south 6

According to Ginulloch. Cat.

a 10th magn. star precedes 58ˢ, north 2ʹ

 9.6 " " precedes 25ˢ, south 7ʹ

 10 " " follows 20ˢ south 6ʹ

defined time periods. She noted the dip to minimum beginning again the cycle. She recorded and sorted; she compiled tables from years of sky patrol photographs. Everything she did depended on the telescope, but she had no physical connection to the telescope's observations or to the photographic process. Henrietta's telescope was a half a world away, the twenty-four-inch Bruce reflector near Arequipa, Peru. She made her discoveries in the Magellanic clouds in a night sky she would never see above Cambridge. How unromantic. How removed from the thrust of exploration.

How different from Edwin Hubble, who lived grounded in the night—waiting for clear skies and good seeing. How romantic, Hubble with his perennial pipe jutting jauntily from the corner of his mouth. Photogenic, Hubble made the most of many opportunities. Almost always he is captured with his pipe, smoke circling up, resembling a nebula. In the most famous photograph he stands, pipe clenched in teeth, next to the erect, two-hundred-inch telescope at the Mt. Palomar Observatory. Hubble's world was similar to Pickering's, a big world with a big audience, sailing to world conferences, presenting papers here and there.

Henrietta Leavitt's world was small. For nineteen years she sat at a table in the Harvard College Observatory. It sounds tedious and boring, poring over murky glass plates with little black dots. She tracked the same bit of sky on each 8 x 10 glass, measuring the star as it pulsed bigger and bigger, brighter and brighter, fell back to dimmer and dimmer, then repeated the cycle with precision. What kind of job was this for a young, college-educated woman at the turn of the twentieth century? Actually, it was a very good position.

Assigned a unique, specific task, she concentrated on computing, compiling tables that listed the periods of these variable stars, calculating the data from congruent plates in a cozy, wallpapered workroom, cheek by jowl with up to two dozen other women. They were called computers. Pickering used their findings to publish his papers. It is easy to read this as exploitation by the power, obviously male, of the staff, obviously female. But this was an employment opportunity open only to women. In the first years of the twentieth century places for professional

women were remarkably few; even the female secretary was still in the future.

This was not clerical work. These computers were thinkers, not recorders of others' ideas. Sifting through reams of data provides perspective to make leaps. Intuition often springs from a sure base of knowledge. Pickering hired these women and he believed in their abilities. Annie Jump Cannon, one of Henrietta's coterie, wrote: "He treated them as equals in the astronomical world and his attitude toward them was as full of courtesy as if he were meeting them at a social gathering."[3]

Pickering did much for women in astronomy. Two especially made their mark because they did publish under their own names. Annie Jump Cannon reorganized the spectral luminosity catalogue to correct errors in the scale from bright to faint. This resulted in the acronym OBAFGKM. She popularized the familiar phrase Oh Be A Fine Guy (or Girl) Kiss Me, a helpful mnemonic, in her well known paper, "The Architecture of the Celestial Mansions." Cecilia Payne Gaposchkin posited that stars are mostly hydrogen. These women were prolific writers and their personal histories are well documented.

Henrietta Leavitt intrigues us because she remains a silent figure. She left no writings beyond scientific papers. Any intellectual activity (and many non-intellectual activities) depends on sorting and classifying. Getting the data begins the enterprise. Certainly Hubble ordered and reordered his findings, as does any good thinker. Yet there is something perhaps more akin to the role of the artist in work of Henrietta Leavitt, and her companion computers at HCO, simply because the work emanates from process itself.

In the 1960s, attention to the steps in a process and the incorporation of sorting and cataloguing began to be very important in making art. Methodology, journals, and records of all kinds are common threads in minimalism, conceptual art, and environmental art, all of which developed at this time. Robert Smithson's writings, jottings, diaries of journeys, collecting and organizing of objects are as important as the works themselves.

Henrietta Leavitt, reserved, distanced from the fulcrum of activity, oper-

Friday, December 27, 1918. 45

<u>012233</u> b R S Sculptoris. Cont.

The star marked R S Sculptoris (?) on
sample chart is not in the position
as indicated by the Gesellschaft position
It is 25° south of R Sculptoris instead
of 22°.

The figure is drawn from Plate
A 3344. The designations a, b, c,
are taken from the sample chart.
Stars b, c, and one other star, desig-
nated by crosses, seem to be the
stars referred to in the gesell-
schaft. The point ⊕ agrees with the
position referred to them and to R Sculptoris
No star in this position is seen on A 3344,
(Oct 19, 1898) A 3399 (Nov. 12, 1898) both of which show
stars of the 15th magnitude or fainter. No variation
is seen in the star 3° south of the position
(marked RS? on chart) nor in any other star
near by. The following plates were also examined

B 42872	Dec. 1, 1911		B 34715	Aug. 19, 1904
42761	Oct 3, 1911		28104	Aug. 2, 1901
41839	Aug 24, 1911		25774	Aug 29, 1900
39717	Nov. 3, 1908		23342	July 6, 1899
37104	Oct. 9, 1905		14272	Aug 1, 1895
11837	Aug. 11, 1894		12697	Dec. 13, 1894

No object seen in required position and no
object near by shows variability. Stars of magn. 13 or
fainter seen.

Friday, January 23, 1920

Examination of Stars suspected of Va
by Rev. A. Solberg of Natal, South Af
See letter of Nov

The Stars 1 = C.P.D. −63° 1642 $10\ \frac{2}{4}\ \frac{m}{20.6}$ −6
1573
2 = −64° 1408 10 36.7 −6
10 36.3 −6

are suspected of changing in relati
brightness. Star 1 is the one suspected by so
Beginning of 1918, 1 > 2 1 < 2
Aug. Sept " 1 > 2
Nov " 1 < 2
Dec " − Jan. 1919 1 < > 2
Feb " − May 1919 1 < 2
The above are Mr. Solberg's Observations.

Examined on the plates given on
following page. On blue plates Star
1 is always about 0.3 magn fainter
than a = −63° 1672 , 0.2 magn brighter
than No. 2. No. 2 is always about
0.1 magn brighter than b = −63° 1534
and about 0.5 magn brighter than c = −64

On yellow plates the estimated
relative magnitudes are about the
same. No variation seen.
Could Mr. Solberg's observations
affected by hour angle?
C.P.D magnitudes: − 1, 7.0 ; 2, 7.3 ; a, 7.0 ; b, 7.
Plates at −45° do not cover region

ates as a scientist and as an artist. She is an observer, recorder and collaborator. The exhibition embodied Henrietta Leavitt's presence through work and that work is revealed in objects: the glass plates, the plate holder, the measuring engine, the desk. Several instruments from her era accompany "Henrietta's Stars." The measuring engine was a typical piece of laboratory equipment; its mechanical appearance contrasts with the digital equipment in labs today. The glass plate holder, with its mirror beneath, aided in illuminating the dark spots, the stars. Choosing a negative and placing it over a positive photographed at same location, she matched the black dot to the white dot on the positive. She looked at many plates photographed at the same location on different nights. If the dot grew in size, the star was changing, becoming brighter. She charted the length of the cycle, the amount of time in the variable star's period. She opened one of her beige, cloth-bound notebooks and wrote down her findings.

And Henrietta Leavitt is one of the five luminaries interviewed in the gathering that preceded the performances of *Makrokosmos III*. She was aloof, but Charles and Ray Eames, Rainer Maria Rilke, and Hubble all knew who she was.

During the performance the wall of glass plates, "Henrietta's Stars," was not yet installed, but her desk testified to her presence. She showed lantern slides from HCO's comprehensive collection and tended to other projects. She was in her own world, methodically sorting through the data, selecting images, projecting them. Positioned in the future, Hubble remained a ghost to her. In one moment during the performance Henrietta Leavitt and Edwin Hubble's glances crossed, but this was visible only in the live-feed projection. The audience saw a convergence that the two astronomers could not see. Hubble paid attention to her, for surely he recognized her contribution and worth. She didn't see him; she remained on task, projecting the universe.

1 Edward C. Pickering and Henrietta S. Leavitt, *Periods of 25 Variable Stars in the Small Magellanic Cloud*, "Harvard College Observatory Circular 173 (3 March 1912): 1–3.

2 Dennis Richard Danielson, ed., *The Book of the Cosmos: Imagining the Universe from Heraclitus to Hawking* (Cambridge, Massachusetts: Perseus Publishing, 2000), 395.

3 Bessie Zaban Jones and Lyle Gifford Boyd, *The Harvard College Observatory: The First Four Directorships, 1839–1919* (Cambridge, Massachusetts: Belknap Press of Harvard University Press, 1971), 390.

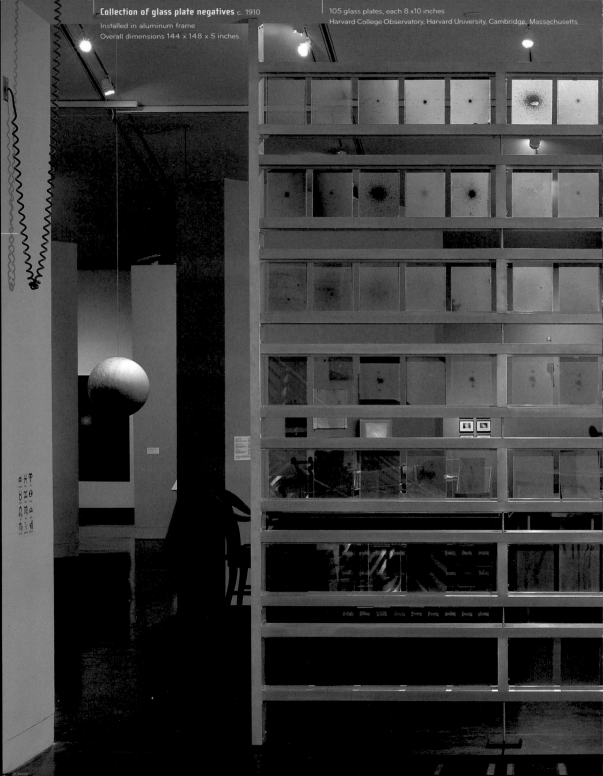

Collection of glass plate negatives c. 1910
Installed in aluminum frame
Overall dimensions 144 x 148 x 5 inches

105 glass plates, each 8 x10 inches
Harvard College Observatory, Harvard University, Cambridge, Massachusetts

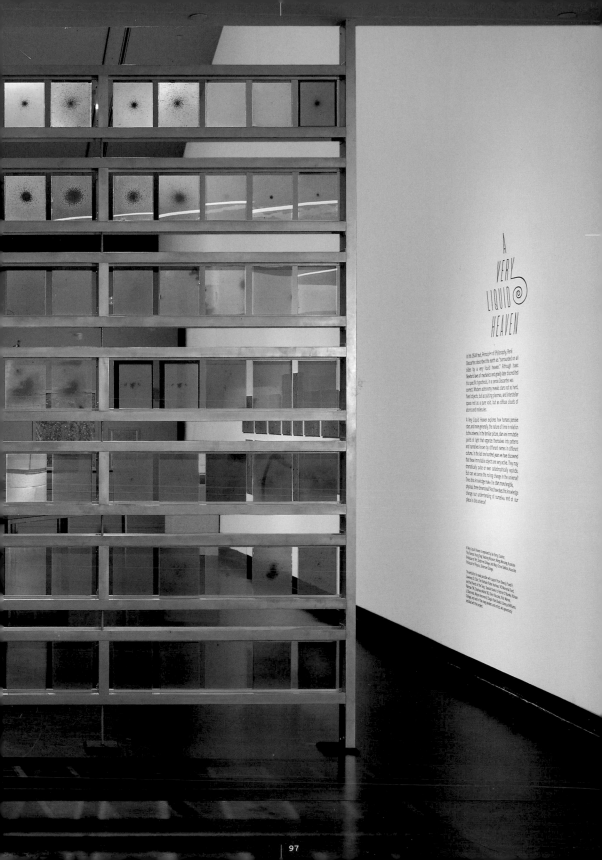

VIJA CELMINS
Strata, 1983

Mezzotint
29 1/4 x 35 1/4 inches
Collection of Jack Shear, Spencertown, New York

JOHN TORREANO
Supernova Remnant in Cassiopeia, 2003

Gesso, krylon, wooden balls, gems on plywood on aluminum frames
120 x 180 inches
Courtesy of the artist and Feature Inc., New York

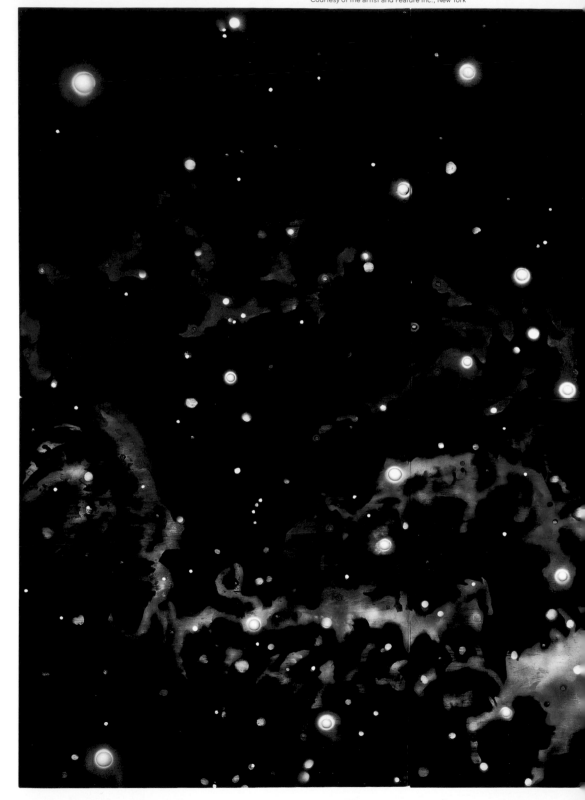

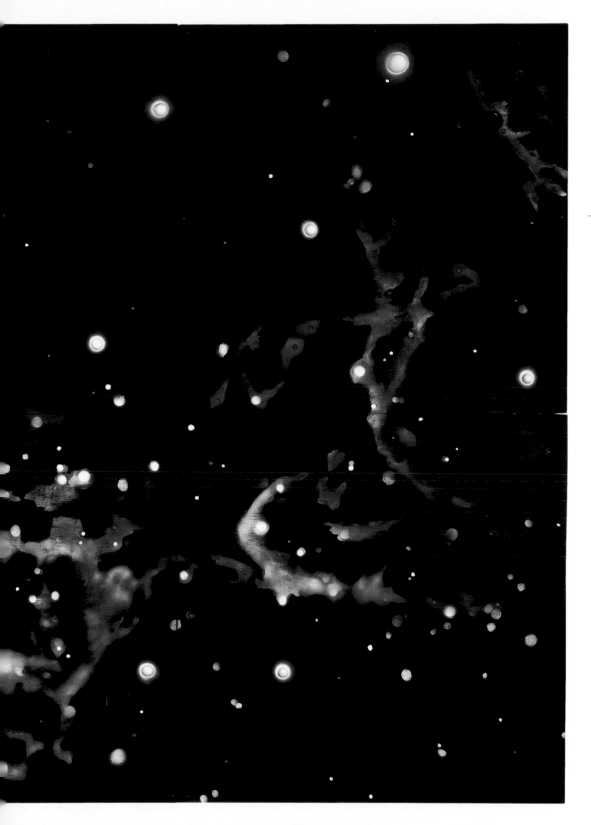

THIS IS NOT
A STAR

THE TITLE *A VERY LIQUID HEAVEN* CLASHES with the traditional picture of stars as unchanging points in the sky surrounded by emptiness. For me, it conjures instead an image of stars as pulsing, turbulent liquid-like balls of plasma. The exhibition highlights the contrast and interplay between these different ways of visualizing stars, and the special role of visual imagery in astronomy.

Visual imagery may play a greater role in astonomy than in any other scientific field. In most sciences, there is an enormous difference between an object of scientific study (perhaps an animal or a DNA molecule), and a visual image of that object (perhaps a photograph or diagram). The object itself can be manipulated. It can be viewed from different directions and distances, picked up, or broken. The object itself shows its appearance in the present, while an image shows its appearance in the past.

Astronomy is different. It is an "observational" science rather than an "experimental" science. We cannot manipulate stars, or travel to their far side for a different perspective. We see the stars as they existed years in the past, when the light we see first left their surface on its journey through space. In some sense, we *only* see visual representations of stars, even as we gaze at them in the sky with unaided eyes. In fact, only one piece in the exhibit actually comes from space itself: a collection of three iron meteorites, sculpted by earth's atmosphere during their brief performance as "shooting stars." Nearly everything else in the exhibit is terrestrial, an earthly representation of something in space.

Thus our inability to manipulate stars intensifies the meaning attached to images in astronomy. I believe it also intensifies *interest* in astronomy, because this fundamental limitation directs us into the satisfying and productive realm of visual imagery.

LIMITATIONS

Any one image does a poor job of encapsulating the full nature of its subject. Even in astronomy, where we cannot change perspective or lighting scheme, we can show the same thing in an infinite number of ways. Consider the Orion

nebula, a cloud of atoms, molecules, dust, and young stars about fifteen hundred light years from earth. In the exhibition we show six images of Orion that differ from each other in a variety of ways, including field of view, wavelength sensitivity, exposure time, and special processing techniques. Besides illustrating the impossibility of fully describing any object through one single image, this collection of images refutes the idea that there is one "correct," "best," or "scientific" way to visualize an object.

As a further complication to interpreting astronomical images, consider that most images of space show a great variety of objects located at a great variety of distances from us, from satellites barely above the earth's atmosphere out to galaxies billions of light years away. We see the satellites as they appeared just a fraction of a second ago, but the distant galaxies as they appeared billions of years in the past. In some sense, the complete scene in the image never existed: each layer existed at a different time, foreshortened into one illusory snapshot.

VISUAL INTUITION AND SCIENTIFIC PROGRESS

When asked by the French mathematician Jacques Hadamard to describe his mental process, Einstein replied, "The words or the language, as they are written or spoken, do not seem to play any role in my mechanism of thought. The psychical entities which seem to serve as elements in thought are certain signs and more or less clear images which can be 'voluntarily' reproduced and combined." A prolific writer on many subjects, Einstein certainly valued verbal communication. But his creative process was driven by imagery. In particular, Einstein and many other early twentieth-century theoretical scientists considered a theory incomplete unless it was "visualizable": the theory could be unfamiliar, even bizarre, but it must be consistent with some mental picture. The atom as a tiny solar system, with electrons in planetary orbits around the atomic nucleus, is an example of such a mental picture, one that persists despite the fact that it actually does a poor job of describing atomic behavior. In fact, the combination of experimental results in quantum physics does not seem to match any really

visualizable model. And yet some descriptions of the quantum world are less visualizable than others. As the Austrian physicist Erwin Schrödinger said in 1926, "I knew of [Werner Heisenberg's] theory, of course, but felt discouraged, not to say repelled, by the methods of the transcendental algebra, which appeared very difficult to me, and by the lack of visualizability."[2]

To contemporary physicists, this insistence on visualizability might sound quaint, if not silly. Why should behavior on a subatomic scale be visualizable, when our ability to visualize evolved by observing nature on a human scale? Today, mathematical elegance may have outstripped any other criterion in theoretical physics. But perhaps the search for visualizable models should not be abandoned, if only because we are much smarter when we deal with them. They allow us access to an intuition for patterns and connections more powerful than any list of logical steps. After all, humans still beat computers at face recognition, and at the game Go.

We regularly use simplified models to help us explain and remember things; the trick is not to confuse model with reality. For example, Farquhar nested globes provide a way to envision the constellations visible on a specific date and from a specific location. The inner globe represents the Earth, and the outer globe shows the constellations as they would appear to you if you were a tiny person on the inner globe. As the Earth spins, the constellations "above you" (in other words, not blocked by the Earth) change. A small yellow ball indicates the direction of the Sun relative to the constellations, which changes slowly over the course of the year. The constellations that appear near the Sun are not visible to us because of the Sun's glaring light. Farquhar globes recall the ancient model of the "crystal spheres." Aristotle believed that the stars really were fixed to a sphere surrounding the Earth, and this picture lasted in Europe for nearly two thousand years.

Apparently, our brains are good at using visual models, but not good at discarding them.

PETRUS APIANUS
Cosmographicus, 1533

8 1/2 x 6 3/8 inches
Dudley Observatory, Special collections. Schaffer Library,
Union College, Schenectady, New York

TERROR AND MYSTERY

The long-lasting popularity of Aristotle's crystal spheres suggests that astro-
nomical images fulfill psychological needs as well. For some people, the myster-
ies of the universe translate into terror, and visualizing the universe allows them
to fathom the unfathomable. Seventeenth-century mathematician and philoso-
pher Blaise Pascal was one of those terrified by the universe. His eloquence
deserves a lengthy quotation:

> Let man then contemplate the whole of nature in her full and grand
> majesty, and turn his vision from the low objects which surround him. Let
> him gaze on that brilliant light, set like an eternal lamp to illumine the
> universe; let the earth appear to him a point in comparison with the vast
> circle described by the sun; and let him wonder at the fact that this vast
> circle is itself but a very fine point in comparison with that described by
> the stars in their revolution round the firmament. But if our view be
> arrested there let our imagination pass beyond; it will sooner exhaust the
> power of conception than nature that of supplying material for concep-
> tion. The whole visible world is only an imperceptible atom in the ample
> bosom of nature. No idea approaches it. We may enlarge our conceptions
> beyond all imaginable space; we only produce atoms in comparison with
> the reality of things. It is an infinite sphere, the center of which is every-
> where, the circumference nowhere. In short this is the greatest sensible
> mark of the almighty power of God, that imagination loses itself in that
> thought.
>
> Returning to himself let man consider what he is in comparison
> with all existence; let him regard himself as lost in this remote corner of
> nature; and from the little cell in which he finds himself lodged, I mean the
> universe, let him estimate at their true value the earth, kingdoms, cities,
> and himself. What is a man in the Infinite?
>
> But to show him another prodigy equally astonishing, let him
> examine the most delicate things he knows. Let a mite be given him, with
> its minute body and parts incomparably more minute, limbs with their

MEDIA NOX

OCCIDENS

ORIENS.

MERIDIES.

Nickel-iron Meteorite
Found in Sikhote-Alin, Russia
18 x 14 x 12 inches
Courtesy of The Universe Collection,
Bethany Sciences LLC, New Haven, Connecticut

joints, veins in the limbs, blood in the veins, humours in the blood, drops in the humours, vapours in the drops. Dividing these last things again, let him exhaust his powers of conception, and let the last object at which he can arrive be now that of our discourse. Perhaps he will think that here is the smallest point in nature. I will let him see therein a new abyss. I will paint for him not only the visible universe, but all that he can conceive of nature's immensity in the womb of this abridged atom. Let him see therein an infinity of universes, each of which has its firmament, its planets, its earth, in the same proportion as in the visible world; in each earth animal, and in the last mites, in which he will find again all that the first had, finding still in these others the same thing without end and without cessation. Let him lose himself in wonders as amazing in their littleness as the others in their vastness. For who will not be astounded at the fact that our body, which a little while ago was imperceptible in the universe, itself imperceptible in the bosom of the whole, is now a colossus, a world, or rather a whole in respect of the nothingness which we cannot reach? He who regards himself in this light will be afraid of himself, and observing himself sustained in the body given him by nature between those two abysses of the Infinite and Nothing, will tremble at the sight of these marvels.[3]

A modern response to Pascal's angst is the classic Eames film *Powers of Ten* (1977), which takes the viewer on a tour of the universe of the large and small, zooming out to see clusters of galaxies and zooming in to see quarks in a carbon nucleus. Pascal's terrifying vast and empty spaces are made visible, incarnate, maybe even peaceful; the engineer's practical sense of considering one scale larger and one scale smaller combines with the emotional satisfaction of *seeing* it all.

The words of Pascal also inspired George Crumb as he composed *Music for a Summer Evening (Makrokosmos III)* (1974), and our production of this piece in conjunction with the exhibition.

A very different example of our psychological need to make visual sense of the stars is the creation of constellations out of star patterns on the sky. The

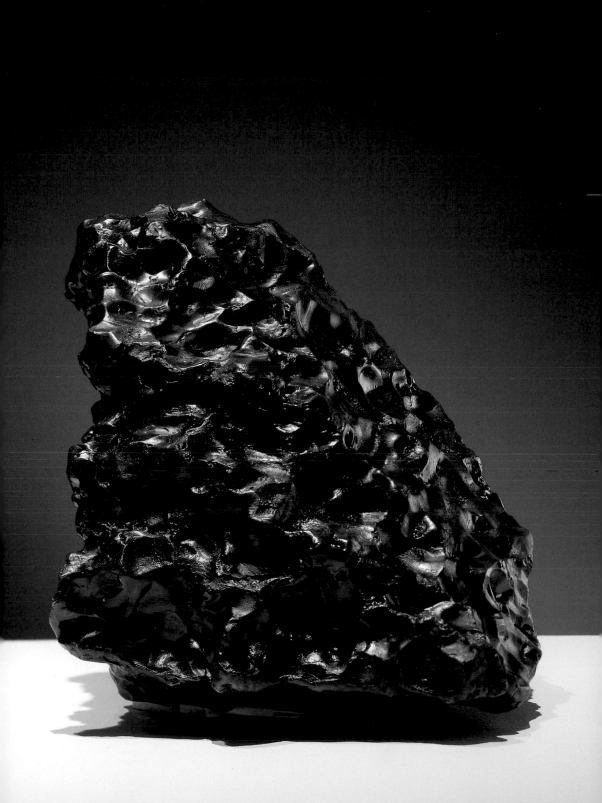

MARGO MENSING
**Collection of Edwin Hubble: Thirteen
Pipes,** 2003

Glass
Dimensions variable
Courtesy of the artist, Gansevoort, New York

figures in celestial atlases have little to do with the appearance of the stars, but are curiously universal. James Evans, author of *The History and Practice of Ancient Astronomy* (1998), concludes that "every culture in which a scientific astronomy developed did devote some effort to organizing the heaven into constellations. Perhaps this was a psychological prerequisite for scientific astronomy."[4]

PIPES

The image of a pipe recurs in the exhibition: the astronomer Edwin Hubble appears, as usual, with pipe in hand; Margo Mensing's glass pipes twirl in the air and sparkle in a display case; Karen Arm's painting *Incense* calls to mind smoke rising in turbulent swirls above an unseen pipe, like the swirling interstellar medium. An additional interpretation of the pipe arises in the context of visual representation. René Magritte's famous painting of a pipe correctly declares itself not a pipe, *"Ceci n'est pas une pipe,"* a reminder that there is indeed a difference between the representation of an object—be it a painting, sculpture, or photograph—and the object itself.

1 Albert Einstein, *Ideas and Opinions* (New York: Crown Publishing, 1954).

2 Arthur I. Miller, *Insights of Genius: Imagery and Creativity in Science and Art* (New York: Copernicus, 1996).

3 Blaise Pascal, *Pensées,* 1670, trans. W. F. Trotter (New York: Random House, 1941).

4 James Evans, *The History and Practice of Ancient Astronomy* (New York: Oxford University Press, 1998).

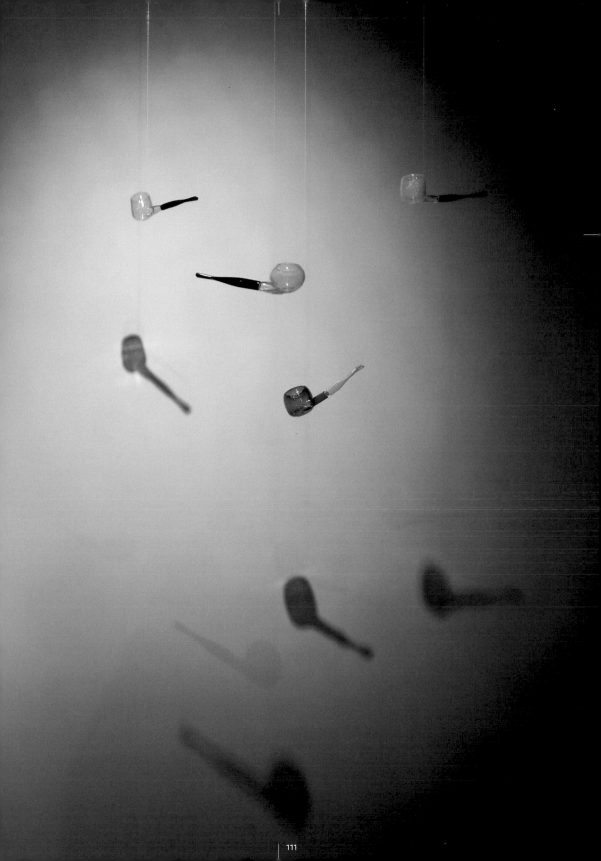

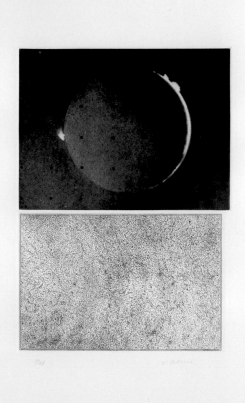

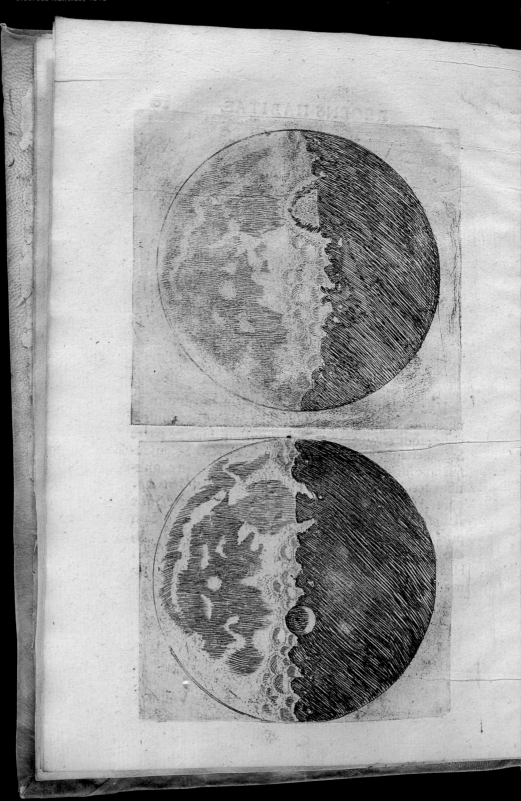

Vnum quoque obliuioni minimè tradam, quod nō nisi aliqua cum admiratione adnotaui: medium quasi Lunæ locum à cauitate quadam occupatum esse reliquis omnibus maiori, ac figura perfectæ rotunditatis; hanc prope quadraturas ambas conspexi eandemque in secundis supra positis figuris quantum licuit imitatus sum. Eundem quo ad obumbrationem, & illuminationem facit aspectum, ac faceret in terris regio consimilis Boemiæ, si montibus altissimis, inque periphæriam perfecti circuli dispositis occluderetur vndique: in Luna enim adeò elatis iugis vallatur, vt extrema hora tenebrosæ Lunæ parti contermina Solis lumine perfusa spectetur, priusquàm lucis vmbræque terminus ad mediam ipsius figuræ diametrum pertingat. De more autem reliquarum macularum, vmbrosa illius pars Solem respicit, luminosa verò versus tenebras Lunæ constituitur; quod tertio libenter obseruandum admoneo, tanquam firmissimum argumentum, asperitatum, inæqualitatumque per totam Lunæ clariorem plagam dispersarum; quarum quidem macularum semper nigriores sunt illæ, quæ confinio luminis, & tenebrarum conterminæ sunt; remotiores verò tum minores, tum obscuræ minus apparent, ita vt tandem cum Luna in oppositione totum impleuerit orbem, modico, admodumque tenui discrimine, cauitatum opacitas ab eminentiarum candore discrepet.

Hæc quæ recensuimus in clarioribus Lunæ regionibus obseruantur, verum in magnis maculis talis nō conspicitur lacunarum, eminentiarumque differentia, qualem necessariò constituere cogimur in parte lucidiori, ob mutationem figurarum ex alia, atque alia illuminatione radiorum Solis, prout multiplici positu Lunam respicit; at in magnis maculis existunt quidem

areolæ

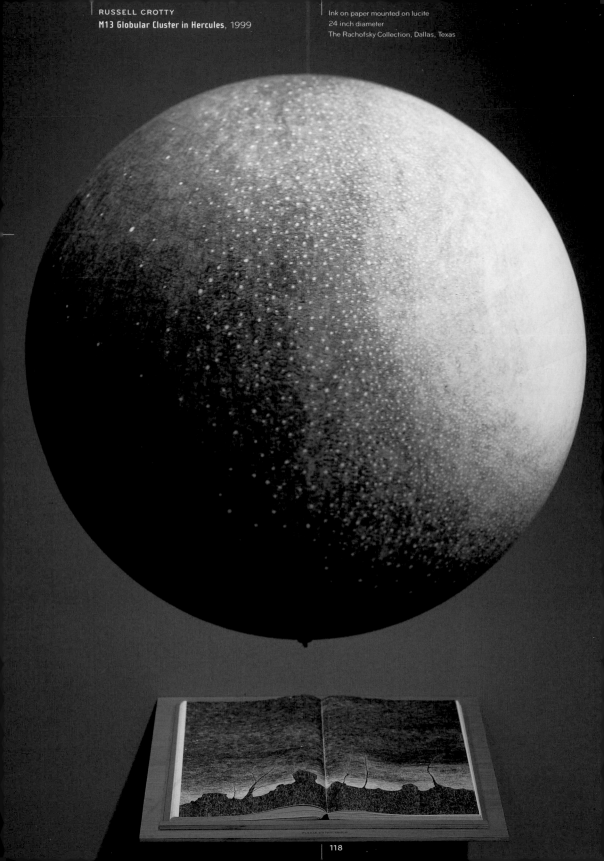

KAREN ARM
Untitled (globular cluster), 2004

Acrylic on canvas
66 x 54 inches
Collection of Serge Marquie, London, United Kingdom

ARTISTS' DIALOGUE

IAN BERRY: Let's start the conversation with a brief description of your work in the exhibition.

RUSSELL CROTTY: I have a globe drawing, a flat drawing of a star cluster, and a book that includes several deep sky observations. I use the telescope in my observatory at home to make thumbnail sketches. After bringing them back to the studio, I use them to make drawings. That is my form of gathering. For me, the flat drawings lead to the spherical drawings. I kept thinking what would the flat globular star cluster look like on a sphere and that led to the globe series. My method is old-fashioned scientific observation that does not rely on computer or other automated systems. Astronomers today take information back to the research institution where they are used help crunch numbers. I am stuck in the nineteenth century, interestingly enough, before the glass plates on view in this exhibition. Photography was sort of the death knell for the visual, in this case for astronomers sitting and drawing at the eyepiece. I think in the context of the show it is really interesting to start with the glass plates—that is basically the start of modern astrophysics.

JOHN TORREANO: I have a large painting on view called *Super Nova Remnant in Cassiopeia* and it is directly inspired by a photo image from the Hubble Space Telescope. For about forty years I have been using space imagery in my work because I like the way outer space concepts parallel my ideas about painterly space. I am more interested in how I can make use of the imagery.

IB: Rather than what the image actually is?

JT: Exactly, rather than the fact of its scientific meaning. My painted versions of the images are attempts at creating an empathic connection to those outer space images. I don't feel photography can do that.

what I was getting from the art discourse at the time.

IB: ...and your paintings Karen?

KAREN ARM: I have two paintings on view: one is a globular cluster and the second is an image of incense. I view science as something of a starting point to create an abstraction. I had been working already with some star fields and then re-looking at photographs from the Hubble, and I got to see actual globular clusters. I do look at the stars, and part of what I was interested in was trying to capture something that a photograph can't capture. You know intellectually that that cluster is made of millions and millions of stars and of course they get blurred in the photographs and so I am trying to articulate that idea in paint. I am trying to capture something that is kind of un-capturable.

RC: Like fluid dynamics.

KA: Right. I am interested in physics and using painting as a way to capture particular kinds of physical phenomena in a way that physicists write for-

mulas. When I got interested in physics I could never find enough photographs to use. My husband is a photographer, so he helped me with the research. I used a fast strobe and set up a photo studio in my space to make tons of pictures.

IB: To try to capture the motion of the smoke?

KA: Just to get one that is usable. I am trying to learn about that form which was unbelievably complicated and changing and so I am still being true to the source. There are practical concerns of how to get an image that I can work with, but it is capturing this moment in time and freezing it that I am focused on. But at the same time I want the painting to have a sense of movement. It is like trying to paint air.

IB: How do you think time functions in your work, Russell?

RC: Well, I was just thinking about that. I keep going back to what Stephen Jay Gould said about what he called deep time. The idea is that the ten inches of dust on the surface of the Mohave Desert represents ten thousand years, and then you start to realize just how vast the sweeps of time are. Our world is very slow moving generally, and then you have us humans who have been there in geological time for like that [snaps fingers]. You start realizing distances and ages of these things and the ages of stars. The writing I do is my form of splatter painting—there is a bit of this sentimentality about the time, deep time, and being up in the mountains with the old trees, the rocks, the Milky Way going over, you feel like you are part of it all. It is almost spiritual.

IB: Your work is very grounded in a sort of diary-like recording
of your day-to-day activities.

RC: It is. It does come from that.

IB: And now you are making field guides?

RC: I am getting into the field guide more and more, in terms of rocks and trees. We all have our own interpretations of this stuff, but in an art and science relationship there always seems to be this gray area and then when it finally becomes your work it is something driven by aesthetic decisions.

JT: As artists, we are more involved with how things look.

IB: ...or how you feel about these things you record?

JT: Yes—I wanted to add something about time. My effort in a way is to try to reduce the time of experience so that the concept of fifty million years becomes something that a person viewing a drawing or painting can actually compress into their solar plexus. This makes the function of the physical aspects in the painting, the drilling and the sanding, all of that is a way to set the stage so that when the viewer looks at it—it winks at them. You are in this moment in this space, so that you are actually brought into it in a way that is in the scale of being a human being. I like what you said before, Russell, about how scientists use these images as data and for mathematics. That is a critical difference between our two enterprises.

Perception is an area that is very much in the space of difference between art and science. Because science is constantly striving for the truth and knowledge of facts and it can only be based on what levels of perceptual mechanism that they have at any given time in the history of being a scientist.

IB: Russell, you recently described this moment that we are in now as a real place of freedom for you, because of how little we know about some of these things. Can you describe that idea?

RC: There was a video interview with a bunch of scientists called, *A Glorious Accident: Understanding Our Place in the Cosmic Puzzle*. In the end, a man looks at a glass of water on the table and he says, "We really don't know what that is." When I heard that, I thought that is so freeing. We don't know what that is, we can try to find out, ask questions, but we don't know.

JT: That is very interesting. I use a similar example of what art is as compared to what craft is for my students. I say craft is doing what you already know how to do and art is doing what you don't know how to do. One is knowledge and one is mystery. You've got to have both. If you don't have any knowledge, then who wants to look at what you are doing, and if you only have mystery, then you are insane.

IB: Each one of you has an element of obsession in your practice— whether it's your attention to details or your everyday process, or your layering. What do you gain from that obsessive repetition?

JT: I don't feel that it's repetitious for me. Although in hindsight it would look that way, to me it's an effort to try to make it work right. So I put stuff on and I take stuff off and put it back on until eventually it settles to a place where it is doing what I thought I wanted, and then I will sit on it for a while and I'll want to work on it again. It may be compulsive in that I am not satisfied, but not repetitious, per se.

KA: For me, that process is the only way to depict what I am capturing. It almost forces me to want to be more obsessive. With the stars and smoke, you keep going in and in and in and there is more and more information. There is always more.

RC: Well, actually, vision is similar. If you look through a large aperture

sized scope and a very dark night.

KA: Right—I really want to try to get that. Even in the drawings I am doing now I am trying to make these images of the sun where I want to put in so many dots that it really becomes solid.

JT: Are those solar faculae?

KA: Yes, I am playing with those phenomena. Right now I am still using dots, but I may actually change the mark to get it just right.

RC: What is so great about the solar faculae is that it is just moving gases. It is just a bright spot from heat—gas and heat—and it is just swimming around rising and falling, back and forth.

KA: And it looks like smoke. I have some photographs from National Geographic and it looks like the same pattern that the smoke makes. Those patterns are found everywhere.

RC: In the nineteenth century they made drawings of that and talked about different ways to perceive a moving thing. Trying to draw something that is moving, they came up with this overlay of stiff patterns.

KA: What is tricky is how to keep the dots even though they may get obliterated, but it is important for me to have them there.

RC: I like the idea of obliterating the dots.

KA: I do a lot of that. I have done a whole series of droplet paintings and

men I paint mem out, so they are hardly mere, but they need to be mere. Then I do a whole other layer. Viewers may perceive those as insanely obsessive decisions, but to me, that's part of what makes the image moving. I can't do these paintings quickly.

RC: That is what I was going to say in terms of my process, it is taking a long time on each piece, like a book can take eight months, not every day, but living with those things for a while. Each one takes on its own characteristic, even within the limited scope of how I work, like these pens and paper. Reducing the material and process has been beneficial for me psychologically to be able to get a little more complexity.

JT: ...let it take its own time.

RC: Right, delve into these things that are more complex rather than relying on material to do tricky things—although I am jealous of making dots disappear with paint. That is so tempting. For me my daily thing is to get up and go to work, it is my routine. Go climb a tree and come back—from point A to point B

DUANE MICHALS
The Human Condition, 1969

Six framed gelatin-silver photographs
5 x 7 inches each
Courtesy of the artist and Pace/MacGill Gallery, New York

THE HUMAN CONDITION

2

3

SLATER BRADLEY
Theory and Observation, 2002

Video with sound
4:02 minutes
Courtesy of the artist and Team Gallery, New York

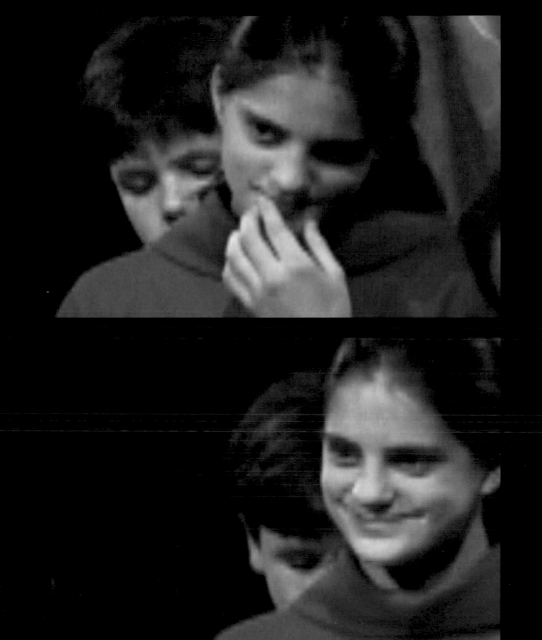

this page and following four spreads:

CHARLES AND RAY EAMES

Details from Powers of Ten, 1977

this page:

10 meters, 10^1 meters

Video with sound
8:47 minutes
Courtesy of the Eames Office

CONTRIBUTORS

☉ **PETRUS APIANUS** (1495–1552) was a German scholar and teacher whose mid-sixteenth century *Cosmographicus* provided a layman's introduction to subjects such as astronomy, geography, cartography, navigation, and mathematics. The book featured one of the earliest known instances of moveable parts within a bound volume. These parts, called volvelles, allowed users to calculate the positions of the Sun, Moon, and planets.

♌ **KAREN ARM** (b. 1962) received her BFA from the Cooper Union in 1985; a master's degree from Columbia University followed in 1989. Since then Arm has exhibited her obsessively detailed yet soothing paintings at numerous venues across the United States, with her first solo exhibition at Pierogi in Brooklyn, New York in 1998. A 2002 recipient of a New York Foundation for the Arts Fellowship for Painting, Karen Arm lives and works in Brooklyn and Shelter Island, New York is currently represented by the P.P.O.W. in New York.

JOHANNES BAYER (1572–1625), a lawyer and amateur astronomer, produced the first extensive star atlas in the Western world: the *Uranometria* of 1603. Recognized as a milestone work both for its institution of a letter-based system of star nomenclature that is still in use and for the beauty of its illustrated plates, the *Uranometria* has become a standard reference point for all later star atlases.

△ **IAN BERRY** (b. 1971) is the Susan Rabinowitz Malloy '45 Curator of the Tang Teaching Museum and Art Gallery at Skidmore College. He received his MA from the Center for Curatorial Studies at Bard College, and served as Assistant Curator at the Williams College Museum of Art before coming to Skidmore. A specialist in contemporary art, Berry is currently working on retrospective exhibitions of the work of Richard Pettibone and the collaborative team of Kate Ericson and Mel Ziegler.

✳ **JOHN BEVIS** (1695–1771) was a British amateur astronomer best known for his discovery of the Crab Nebula in 1731. Bevis also attempted to produce the most accurate and beautiful of all celestial atlases to date, one that would follow the example of Johannes Bayer but include all of the many new stars and nebulous objects that had recently been discovered. Legal troubles hindered production, however, and printed copies of Bevis's *Uranographia Britannica* are extremely rare.

△ **JOHANN ELERT BODE** (1747–1826) was a member of the Berlin Academy of Sciences and the director of the Berlin Observatory for nearly forty years. He was the author of a popular astronomy book, *Instruction for the Knowledge of the Starry Heavens*, in which he presented a formula to express the relative distances of the planets from the sun, now called Bode's Law. He observed numerous star

clusters, nebulae, and comets for the first time; he was also especially interested in the newly discovered planet Uranus, whose name he had proposed. Bode's popular *Uranographia* of 1801 was the most extensive celestial atlas ever published, recording over 17,000 stars.

△ **SLATER BRADLEY** (b. 1975) received his education at the University of California, Los Angeles, graduating with a BA in 1998. A native of San Francisco, Bradley is now represented by Team Gallery in New York. Bradley has shown his videos, photographs, and installations in solo exhibitions in New York, Los Angeles, Paris, Berlin, Geneva, and London, and has been featured in numerous group exhibitions. His piece, *Theory and Observation*, garnered critical acclaim at the 2004 Whitney Biennial, while his recent solo exhibition, *Stoned & Dethroned*, featured photographs of Nirvana frontman Kurt Cobain as reenacted by Bradley's friend (and fellow artist) Benjamin Brock.

✳ **VIJA CELMINS** (b. 1938) was born in Riga, Latvia and in 1949 immigrated with her family to the United States, settling in Indianapolis. There she received a BFA from the John Herron Institute; she later earned a MFA in painting from the University of California, Los Angeles. A highly respected artist best known for her precise gray and black renditions of the night sky, seascapes, and the desert floor, Celmins was a 1997 recipient of a MacArthur Fellowship. Her work has been the subject of multiple retrospective exhibitions, including shows organized by the Museum of Fine Arts Houston, the Institute of Contemporary Art in London, and the Metropolitan Museum of Art.

♌ **RUSSELL CROTTY** (b. 1956) graduated with honors from the San Francisco Art Institute in 1978, with an MFA from the University of California, Irvine following directly. Initially recognized for his ballpoint pen drawings of surfers and waves, Crotty now makes drawings of constellations, planets, and stars at his self-built observatory on the Malibu coast. Crotty has exhibited his drawings, books, and globes in numerous shows worldwide; recent solo exhibitions were held at the Kemper Museum of Contemporary Art, the Contemporary Arts Museum Houston, and the Miami Art Museum.

✳ **GEORGE CRUMB** (b. 1929) earned his doctorate from the University of Michigan, Ann Arbor in 1959, and spent more than thirty years teaching music at the University of Pennsylvania. Crumb's compositions are known for their symbolic, mystical, or theatrical elements, and often combine traditional Western music motifs with hymns, folk music, and non-Western musical styles. Consistently recognized for his talent and contributions to his field, Crumb is the recipient of six honorary degrees, two Guggenheim grants, the 1968 Pulitzer Prize for music, a 2001 Grammy Award, and was named the 2004 Musical America "Composer of the Year."

⩒ **JOHANN DOPPELMAYR** (1677-1750) was a scholar of astronomy, geography, physics, and other related subjects, and was a professor of mathematics at Nuremberg for nearly fifty years. Known for creating maps and globes of both the Earth and the heavens, Doppelmayr's most influential work was his *Atlas Coelestis* (1742), a collection of most of the astronomical and cosmographical plates that he produced over thirty-five years. The *Atlas Coelestis* included plates on stars and constellations, solar eclipses, comets, terrestrial and lunar maps, and the arrangement and motions of the planets and their satellites.

(o) **CHARLES EAMES** (1907-1978) and

☐ **RAY EAMES** (1912-1988) collaborated in developing affordable modern architecture, designing innovative furniture and traveling exhibitions, and producing educational films from the 1940s to the 1970s. The Eameses believed that good design—that which was simple, comfortable, useful, and also beautiful—should be available to all people and extended into all areas of daily life. Today their molded plywood furniture is highly coveted among collectors, their film *Powers of Ten* has become an educational staple, and a comprehensive exhibition of their work organized by the Library of Congress traveled worldwide from 1999 to 2002.

⩒ **DEBRA FERNANDEZ** (b. 1952) has been an Associate Professor of Dance at Skidmore College since 1991, where she teaches the Ballet and Jazz Workshops that develop new and original choreography in collaboration with students. Fernandez' choreography has been seen at numerous venues throughout the northeast, including Five Myles, MASS MoCA, the Williamstown Theater Festival, and the Tang Teaching Museum and Art Gallery. She has worked with the Williamstown Theater Festival as a movement instructor, coach, and choreographer for several years, and is an active member of mad dog, an experimental theater company based in Brooklyn, New York.

♌ **JOHN FLAMSTEED** (1646-1719) was appointed the first Royal astronomical observer by the decree of King Charles II in 1675. The Royal Observatory at Greenwich was built and equipped for his use and Flamsteed began observing there in 1676. With the facilities of the observatory at his disposal, Flamsteed became the first to produce a catalogue of the positions and magnitudes of the northern stars that used the aid of telescopic measurement. Another of his major accomplishments was the invention of a conical projection—a projection of the sphere onto a plane that became very useful in subsequent cartography.

GALILEO GALILEI (1564–1642), Italian mathematician, physicist, astronomer, and philosopher of the early seventeenth century, is perhaps most famous for his early use of the telescope. His 1609 telescope (with 20x magnification) was powerful enough to observe the remnants of a supernova, the details of the Moon's surface, four satellites of Jupiter, the phases of Venus, and the movement of sunspots. His discovery of the Jovian moons in particular offered justification for Copernicanism by demonstrating that there were orbiting heavenly bodies that did not revolve exclusively around the earth. This assertion caused problems with the Inquisition for Galileo; in 1633 he was sentenced to house arrest for the remainder of his life. The Catholic Church finally relented in 1992, officially pardoning Galileo nearly four hundred years after his initial conviction.

MARGARET J. GELLER (b. 1947) is a Senior Scientist at the Smithsonian Astrophysical Observatory, where she and her collaborators have been working to construct three-dimensional maps of the known universe. Geller's research has provided scientists and laymen alike with a surprising image of the universe: rather than being scattered in a random fashion, galaxies are systematically clustered in thin sheets over enormous voids, similar to soap bubbles. Her films about astronomy have won numerous awards, are displayed at many major science museums, and have been widely televised. She received a MacArthur Fellowship and is a member of the National Academy of Sciences.

JOHANNES HEVELIUS (1611–1687) was a respected Polish astronomer who, following the example of Tycho Brahe, used very large (measuring six feet in radius) brass instruments and his naked eye to determine stellar positions. Though many of his fellow astronomers advocated the use of telescopes for this research, Hevelius's results were just as accurate as those acquired with state-of-the-art micrometric telescopes. *Hevelius's Uranographia* was his life's work: a star atlas of unprecedented accuracy that was published posthumously in 1690.

SCOTT J. KENYON (b. 1956) is an astronomer who studies the formation and evolution of planets and stars. A Senior Scientist at the Smithsonian Astrophysical Observatory at Harvard University, Kenyon is especially interested in the objects of the Kuiper Belt—a ring of relatively small rocky bodies orbiting the sun beyond Neptune. Kenyon and his colleagues have developed computer simulation models to develop theories of Kuiper Belt object collisions and their relation to the formation of icy planets. Kenyon's other research projects are focused on the luminous accretion disks that surround newly formed stars—mass flows from these flickering disks into the new stars, increasing their sizes exponentially.

♋ HENRIETTA SWAN LEAVITT (1868–1921) worked at the Harvard College Observatory from 1895 until her death in 1921. During her career Leavitt made extraordinary contributions to the field of astronomy with her study of photographic plates of Cepheid variable stars and her discovery that the brightness of a star is directly proportional to its period (the time between "outbursts" of energy). Leavitt's findings became known as the period/luminosity law—a formula that could be used to determine the distances of stars from the Earth. This law directly contributed to the later discoveries of other astronomers; for example, in 1918 Harlow Shapley used it to calculate the size of the Milky Way, and, in 1924, Edwin Hubble used Leavitt's law to prove the existence of galaxies outside our own.

♂ J. J. V. LITTROW (1781–1840) Joseph Johann von Littrow was an Austrian astronomer and Director of the Vienna Observatory who is supposed to have devised a method for signaling our presence to the inhabitants of either the Moon or Mars. The scheme often attributed to him called for canals to be dug in geometric shapes in the Sahara, filled with water, topped with kerosene and set alight. This story, however, may be apocryphal, despite the fact that von Littrow supported pluralism and possibly even the idea that the moon was inhabited.

♁ DAVID MALIN (b. 1941) is a photographic scientist-astronomer who lives in Australia. Until 2001 he worked at the Anglo-Australian Observatory, and he is currently an Adjunct Professor of Scientific Photography at Royal Melbourne Institute of Technology. Malin's method of photographing celestial objects three times (each with a different colored filter) and then combining those plates into one image has allowed for the creation of stellar images that are colored in ways that it is impossible for the human eye to see.

♍ MARGO MENSING (b. 1941) is an Associate Professor of Studio Art at Skidmore College, where she teaches Textile Arts and Art Theory. She earned a BA in English and an MA in American History at the University of Michigan and an MFA at the School of the Art Institute of Chicago. Her installation works incorporate textile projects and procedures while her materials and medium are chosen to fit each project. She writes and curates and frequently collaborates with others in her art mak-

〒 **DUANE MICHALS** (b. 1932) developed his passion for photography while taking por-traits of the people he encountered during his travels in Russia in 1958. Soon after Michals began working as a commercial photographer, shooting pictures for *Mademoiselle*, *Esquire*, and *Vogue*. Later work by Michals includes sequences of photographs (often including written text or painted marks) that deal with conceptual themes of spirituality, mortality, desire and melancholy. Michals currently has over twenty books of his work in print, and recent exhibitions have been held in New York, Düsseldorf, Brussels, Madrid, Paris, and Milan.

△ **MARY CRONE ODEKON** (b. 1968) is an Associate Professor of Physics at Skidmore College. Her research is focused on the formation of galaxies and the large-scale structure of the uni-verse, which she studies with the help of computer simulations and observations from the Hubble Space Telescope. Crone Odekon earned her BS from the College of William and Mary, and her PhD from the University of Michigan. She has also completed research at the University of Washington, the University of Pittsburgh, and the Harvard Smithsonian Center for Astrophysics.

◡ **ALESSANDRO PICCOLOMINI** (1510–1580) was a prominent scholar and priest in six-teenth century Tuscany. Though a poet, playwright, and translator of Classical texts, Piccolomini is per-haps best known as an astronomer and champion of the Ptolemaic (Earth-centered) worldview. His *De le stelle fisse* was one of the earliest star atlases. It featured depictions of all but one of the constella-tions known to Ptolemy, as well as indications of star magnitudes and placements, but did not include pictorial depictions of the mythological figures associated with the constellations.

♁ **BILLY RENKL** (b. 1963) is an Associate Professor of Graphic Design and Illustration at Austin Peay State University in Clarksville, Tennessee. A specialist in collage and mixed-media draw-ing, Renkl's illustrations are often created from vintage diagrams, charts, and botanical prints. Renkl's work has been published in numerous national publications and has appeared in a variety of exhibi-tions, including shows at the Cumberland Gallery in Nashville, Tennessee, the Downtown Artist Co-op in Clarksville, Tennessee, and the College of Notre Dame of Maryland in Baltimore.

♁ **SEBASTIÁN ROMO** (b. 1973) is a Mexican artist who studied photography and docu-mentary filmmaking while earning a BA in Visual Experimentation from the National School of Visual Arts in Mexico City. Inspired by the Land Art and public art of the 1970s, Romo's recent work has focused on human elements within the urban landscape. Romo has been selected as a resident artist at Art Omi in upstate New York, and at New Views: DUMBO, and has exhibited his photography, sculp-tures, and installations in New York, Mexico, Spain, and Brazil.

△ **KIKI SMITH** (b. 1954) makes sculptures, prints, drawings and photographs. Many of her works investigate themes of the human body, often in clever or disquieting ways. Smith's first solo exhibition was held in 1988 at the Fawbush Gallery in New York. Since then she has exhibited in many galleries and museums worldwide, including a recent solo exhibition of prints at the Museum of Modern Art. Born in Nuremburg, Germany, and raised in New Jersey, Kiki Smith lives and works in New York.

♉ **JOHN TORREANO** (b. 1941) studied at the Cranbrook Academy of Art and Ohio State University in the 1960s, and has been making jewel-encrusted paintings and objects since the early 1970s. His recent work accurately renders images gleaned from the Hubble Space Telescope in mists of spraypaint and a scattering of plastic gems on plywood. Torreano lives and works in New York and exhibits frequently at Feature Inc. and Littlejohn Contemporary in New York. A Professor of Art at New York University's Steinhardt School of Education, Torreano is also a stand-up comedian.

♉ **BILL VIOLA** (b. 1951) received his BFA in Experimental Studio Art from Syracuse University in 1973. Since then Viola has become a trailblazer in the field of video art, inspiring solo exhibitions at museums such as the National Gallery in London, the Stadtische Kunsthalle Düsseldorf, Getty Museum, Guggenheim Museum, and the San Francisco Museum of Modern Art. He represented the United States at the 46th Venice Biennale, and was awarded a MacArthur Fellowship in 1989. Most recently, Viola has been working on a new production of Richard Wagner's opera, *Tristan and Isolde*, in collaboration with director Peter Sellars and conductor Esa-Pekka Salonen.

♉ **MATTHEW WILSON** (b. 1984) is an artist who has written essays on visual literacy, the ethics of Pop art, and reviews of various gallery shows in and around New York. He will graduate from Skidmore College in 2006.

CHECKLIST

BOOKS AND ATLASES

(in chronological order)

PETRUS APIANUS
Cosmographicus, 1533
8 1/2 x 6 3/8 inches
Dudley Observatory, Special
Collections, Schaffer Library, Union
College, Schenectady, New York

ALESSANDRO PICCOLOMINI
De la sfera del mondo, 1540
8 3/4 x 6 3/4 inches
Collection of Jay M. Pasachoff,
Williamstown, Massachusetts

JOHANNES BAYER
Uranometria, 1603
18 x 12 3/4 inches
Collection of Jay M. Pasachoff,
Williamstown, Massachusetts

GALILEO GALILEI
Sidereus Nuncius, 1610
8 5/8 x 6 inches
Collection of Jay M. Pasachoff,
Williamstown, Massachusetts

**Istoria e dimonstrazioni intorno alle
macchie solari**, 1613
9 x 6 7/8 inches
Collection of Jay M. Pasachoff,
Williamstown, Massachusetts

JOHANNES HEVELIUS
**Firmamentum Sobiescianum sive
Uranographia Joh. Hevelii**, 1690
13 3/4 x 16 7/8 inches
Collection of Jay M. Pasachoff,
Williamstown, Massachusetts

GABRIEL DOPPELMAYR
Atlas Coelestis, 1742
21 x 13 1/4 inches
Collection of Jay M. Pasachoff,
Williamstown, Massachusetts

Atlas Novus Coelestis, 1742
21 1/4 x 12 1/4 inches
Dudley Observatory, Special
Collections, Schaffer Library, Union
College, Schenectady, New York

JOHN FLAMSTEED
Atlas celeste, 1776
9 x 6 5/8 inches
Collection of Jay M. Pasachoff,
Williamstown, Massachusetts

JOHN BEVIS
Uranographia Britannica, 1786
14 3/4 x 17 3/4 inches
Collection of Jay M. Pasachoff,
Williamstown, Massachusetts

JOHANN ELERT BODE
**Anleitung zur Kenntniss des
Gestrirnten Himmels**, 1788
8 x 5 1/4 inches
Dudley Observatory, Special
Collections, Schaffer Library, Union
College, Schenectady, New York

Uranographia, 1801
25 1/2 x 18 1/2 inches
Collection of Jay M. Pasachoff,
Williamstown, Massachusetts

J.J.V. LITTROW
Atlas des gestirnten Himmels, 1839
9 3/8 x 8 inches
Dudley Observatory, Union College,
Schenectady, New York

**ROGER SINNOT AND MICHAEL
PERRYMAN**
**Millennium Star Atlas Vol. I: 0-8
Hours**, 1997
13 1/4 x 9 1/2 inches
Collection of Skidmore College
Physics Department, Saratoga
Springs, New York

SCIENTIFIC OBJECTS

Farquhar Transparent Globe,
c. 1960
36 inch diameter
Dudley Observatory, Union College,
Schenectady, New York

Henrietta Swan Leavitt notebook,
1918-1921
10 1/2 x 8 1/4 inches
Harvard College Observatory,
Harvard University, Cambridge,
Massachusetts

Plate holder, c. 1910
Wood with mirror
11 1/2 x 9 1/8 x 18 inches
Harvard College Observatory,
Harvard University, Cambridge,
Massachusetts

Measuring engine, c. 1910
21 3/4 x 35 1/2 x 17 1/4 inches
Harvard College Observatory,
Harvard University, Cambridge,
Massachusetts

Collection of lantern slides,
c. 1950
3,620 slides, each 4 x 3 1/4 inches
Harvard College Observatory,
Harvard University, Cambridge,
Massachusetts

Collection of glass plate negatives,
c. 1910
105 glass plate negatives, each
8 x 10 inches
Harvard College Observatory,
Harvard University, Cambridge,
Massachusetts

COLLECTION OF THREE
NICKEL-IRON METEORITES

"The Creator's Touch"
(found in Sikhote-Alin, Russia)
18 x 14 x 12 inches

"Gateway to Infinity"
(found in Gibeon, Namibia)
9 x 13 x 6 inches

"Peering Into Space"
(found in Gibeon, Namibia)
12 x 14 x 8 inches
All meteors courtesy of The Universe
Collection, Bethany Sciences LLC,
New Haven, Connecticut

SCIENTIFIC DATA

PALOMAR OBSERVATORY
SKY SURVEY
Orion Nebula region, 1958
Black and white photograph
14 x 17 inches
Part of the National Georgraphic
Palomar Sky Survey; taken with the
48-inch Schmidt Telescope at
Mount Palomar, about six degrees
across

DAVID MALIN
The Orion Nebula, M42 and M43,
1979
Digital Print
11 x 13 1/2 inches
Taken with the Anglo-Australian
Telescope, 3 five-minute exposures,
about 32 arcminutes across,
processed using unsharp masking
Courtesy David Malin Images

The Tarantula Nebula and Supernova
1987A in the Large Magellanic
Cloud, 1987
Digital projection
83 x 111 inches
Courtesy David Malin Images

STEVE KOHL AND TILL CREDNER
Orion Constellation, 1995
Digital print
15 3/4 x 10 1/2 inches
Taken from Calar Alto with a f = 55
mm 1/3.5 photo lens on Kodak
Ektachrome 400 Elite film, exposed
60 minutes

THE SAN DIEGO
SUPERCOMPUTER CENTER AND
THE AMERICAN MUSEUM OF
NATURAL HISTORY HAYDEN
PLANETARIUM, AND C.R. O'DELL
Volume Visualization of the Orion
Nebula, 1999
Computer animation
2 minutes
Based on infrared and visible light
observed from the Hubble Space
Telescope and ground-based
imagery

NASA/PENN STATE UNIVERSITY
Orion Nebula Star Cluster, 1999
Digital X-ray image
11 3/8 x 11 3/8 inches
Taken with the Chandra X-ray
Telescope Advanced CCD Imaging
Spectrometer, 17 arc minutes across,
13.3 hours observation time

IRAS/IPAC
The Constellation Orion, 1983
Digital infrared image
11 1/4 x 11 5/8 inches
Taken with Infrared Astronomical
Satellite, composite of wavelength
bands centered at 12 microns, 60
microns, and 100 microns, 30 x 24
degrees

JORDRELL BANK OBSERVATORY
Pulsar sound
Courtesy of the Jodrell Bank
Observatory Pulsar Grqup at the
University of Manchester, England.

MUSICAL SCORE AND
RECORDINGS

GEORGE CRUMB
Notes and score for Music For A
Summer Evening (Makrokosmos III),
1974
Pencil and ink on paper
45 sheets, 11 x 15 1/8 inches each
Collection of George Crumb, Media,
Pennsylvania

Makrokosmos, Volumes I and II,
1972–1973
Audio recording
66:48 minutes
Performed by Robert Shannon
Bridge Records, New Rochelle, New
York, 2004

Music For A Summer Evening
(Makrokosmos III), 1974
Audio recording
Performed by Susan Grace, Alice
Rybak, John Kinzie, and David
Colsom
Bridge Records, New Rochelle, New
York, 2001

TARVIS WATSON
MAK3 Documentary, 2004
Digital video with sound
29:27 minutes
Courtesy of the filmmaker, Brooklyn,
New York

CONTEMPORARY ART

KAREN ARM
Untitled (globular cluster), 2004
Acrylic on canvas
66 x 54 inches
Collection of Serge Marquie,
London, United Kingdom

Untitled (incense #4), 2004
Acrylic on canvas
66 x 48 inches
Courtesy of the artist and P.P.O.W.,
New York

SLATER BRADLEY
Theory and Observation, 2002
Video with sound
4:02 minutes
Courtesy of the artist and Team
Gallery, New York

VIJA CELMINS
Strata, 1983
Mezzotint
29 1/4 x 35 1/4 inches
Collection of Jack Shear,
Spencertown, New York

Alliance, 1983
Aquatint, mezzotint, and drypoint
24 x 19 3/8 inches
Collection of Jack Shear,
Spencertown, New York

Constellation—Ucello, 1983
Aquatint and etching
27 1/4 x 23 1/8 inches
Collection of Jack Shear,
Spencertown, New York

Jupiter moon—Constellation, 1983
Mezzotint
23 3/4 x 18 1/2 inches
Collection of Jack Shear,
Spencertown, New York

RUSSELL CROTTY
M13 Globular Cluster in Hercules,
1999
Ink on paper mounted on lucite
24 inch diameter
The Rachofsky Collection, Dallas,
Texas

M72 Globular Cluster in Aquarius,
1998
Pencil and ink on paper
32 x 32 inches
The Rachofsky Collection, Dallas,
Texas

Atlas of Deep Sky Drawings, 1997
Pencil and ink on paper, 98 pages
33 1/4 x 22 1/4 inches
The Rachofsky Collection, Dallas,
Texas

CHARLES AND RAY EAMES
Powers of Ten, 1977
Video with sound
8:47 minutes
Courtesy of the Eames Office

MARGO MENSING
**Collection of Edwin Hubble: Ten
Pipes**, 2003
Glass
Overall dimensions variable
Courtesy of the artist, Gansevoort,
New York

**Collection of Edwin Hubble: Thirteen
Pipes**, 2003
Glass
Overall dimensions variable
Courtesy of the artist, Gansevoort,
New York

DUANE MICHALS
The Human Condition, 1969
Six framed gelatin-silver photo-
graphs
5 x 7 inches each
Courtesy of the artist and
Pace/MacGill Gallery, New York

BILLY RENKL
**Proposal for a beaded and quilted
silk to be made into a coat for
Galileo**, 2002
Framed mixed media drawing,
40 x 32 inches
Framed quilted French silk damask,
c. 1740
20 1/2 x 14 1/2 inches,
Courtesy of the artist, Clarksville,
Tennessee

SEBASTIÁN ROMO
Constelaciones series, 1997
14 C-prints mounted on sintra
23 x 16 inches each
Collection of William & Anne Palmer,
New York
Courtesy of Greenberg Van Doren
Gallery, New York

KIKI SMITH
Nuit, 1993
Anodized aluminum, bronze,
mohair
Dimensions variable
Williams College Museum of Art,
Museum purchase, Kathryn Hurd
Fund, 94.13

JOHN TORREANO
Supernova Remnant in Cassiopeia,
2003
Gesso, krylon, wooden balls, gems
on aluminum frames
120 x 180 inches
Courtesy of the artist and Feature
Inc., New York

BILL VIOLA
Ancient of Days, 1979–81
Video with sound
12:21 minutes
Courtesy of the artist and EAI,
New York

SUGGESTED
FURTHER READING

Adams, Brooks. "John Torreano: Scarred Diamonds." *ARTnews* 90, no. 2 (February 1991): 120-125.

Albrecht, Donald, et al. *The Work of Charles and Ray Eames: A Legacy of Invention*. Exhibition catalogue. New York: Harry N. Abrams, Inc. in association with the Library of Congress and the Vitra Design Museum, 1997.

Bradley, Slater, and Amada Cruz. *Don't Let Me Disappear*. Exhibition catalogue. Annandale-on-Hudson, New York: Center for Curatorial Studies, Bard College, 2003.

Clair, Jean. ed. *Cosmos: From Romanticism to the Avant-garde*. Exhibition catalogue. Munich: Prestel, in association with The Montreal Museum of Fine Arts, 1999.

Crowe, Michael J. *Modern Theories of the Universe: From Herschel to Hubble*. New York: Dover, 1994.

Danielson, Dennis Richard, ed. *The Book of the Cosmos: Imagining the Universe from Heraclitus to Hawking*. Cambridge, Massachusetts: Perseus Publishing, 2000.

Duncan, Michael, and Anne Gully. *Bigger Than Us: Russell Crotty and Kelly McLane*. Exhibition catalogue. Phoenix, Arizona: Phoenix Art Museum, 2003.

Eames, Charles, and Ray Eames, dirs. *The Powers of Ten*. 1977. Reissued on DVD. Eames Office, 2000.

Evans, James. *The History and Practice of Ancient Astronomy*. New York: Oxford University Press, 1998.

Goldsmith, Donald. *Connecting with the Cosmos: Nine Ways to Experience the Magic and Mystery of the Natural World*. Naperville, Illinois: Sourcebooks, 2002.

Greene, Brian. *The Fabric of the Cosmos: Space, Time, and the Texture of Reality*. New York: Alfred A. Knopf, 2004.

Hubble, Edwin Powell. *The Realm of the Nebulae*. New York: Dover, 1958.

Jones, Bessie Zaban, and Lyle Gifford Boyd. *The Harvard College Observatory: The First Four Directorships, 1839-1919*. Cambridge, Massachusetts: Belknap Press of Harvard University Press, 1971.

Karen Arm: Paintings. Exhibition brochure. New York: P.P.O.W., 2004. Essay by Sarah Schmerler.

Kirkham, Pat. *Charles and Ray Eames: Designers of the Twentieth Century*. Cambridge, Massachusetts: MIT Press, 1995.

Kolb, Rocky. *Blind Watchers of the Sky: The People and Ideas that Shaped Our View of the Universe*. Reading, Massachusetts: Addison-Wesley, 1996.

Livingstone, Marco, ed. *The Essential Duane Michals*. Boston: Little, Brown, 1997.

Malin, David, and Katherine Roucoux. *Heaven and Earth: Unseen by the Naked Eye*. London: Phaidon, 2002.

Miller, Arthur I. *Insights of Genius: Imagery and Creativity in Science and Art*. New York: Copernicus, 1996.

Posner, Helaine, Kiki Smith, and David Frankel. *Kiki Smith*. Boston: Bullfinch, 1998.

Relyea, Lane, Vija Celmins, Robert Gober, and Briony Fer. *Vija Celmins*. London: Phaidon, 2004.

Rippner, Samantha. *The Prints of Vija Celmins*. Exhibition catalogue. New Haven, Connecticut: Yale University Press, in association with the Metropolitan Museum of Art, 2002.

Ross, David A. and Peter Sellars. *Bill Viola*. Exhibition catalogue. New York: Whitney Museum of American Art, 1997.

Self, Dana. *Russell Crotty: Globe Drawings*. Exhibition brochure. Kansas City, Missouri: Kemper Museum of Contemporary Art, 2003.

The Masters Series: Duane Michals / What Not All. Exhibition catalogue. New York: Visual Arts Press, Ltd. in association with the Visual Arts Museum at the School of Visual Arts, 2000. Essay by Richard Whelan.

Viola, Bill. *Reasons for Knocking at an Empty House: Writings 1973-1994*. Cambridge, Massachusetts, and London: MIT Press in association with Anthony d'Offay Gallery, 1995.

Yokobosky, Matthew. *Speed of Vision: On the Construction and Perception of Time in Video Art*. Exhibition catalogue. Ridgefield, Connecticut: Aldrich Contemporary Art Museum, 2000.

ACKNOWLEDGMENTS

IN HIS 1644 TEXT, *PRINCIPLES OF PHILOSOPHY*, René Descartes described the earth as "surrounded on all sides by a very liquid heaven." Although Isaac Newton's laws of mechanics and gravity later discredited his specific hypothesis, in a sense Descartes was correct. Modern astronomy reveals stars not as hard, fixed objects, but as pulsing plasmas, and interstellar space not as a pure void, but as diffuse clouds of atoms and molecules.

Partly inspired by this quote, we set out to create the exhibition *A Very Liquid Heaven* to explore how humans perceive the stars, and more generally, the nature of time in relation to the universe. In the familiar picture, stars are immutable points of light that organize themselves into patterns and narratives known by different names in different cultures. In the last one hundred years we have discovered that these immutable objects are very active. They may dramatically pulse or even catastrophically explode. But can we sense the roiling change in the universe? Does this knowledge make the stars more tangible, physical, and three-dimensional? And how does this knowledge change our understanding of ourselves and of our place in the universe?

We chose a wide variety of object—from the sound of a pulsar to books by Galileo to a cast metal sculpture by Kiki Smith—to drive our interrogation of these questions and we have many people to thank for their help with our project. For their generous loans we would like to thank: Jay M. Pasachoff; Dudley Observatory and Special Collections, Schaffer Library, Union College, Schenectady, New York; Harvard College Observatory, Cambridge, Massachusetts; Beverly P. and R. Lawrence St. Clair; Steve Kohl and Till Credner; David Malin; The San Diego Supercomputer Center and the American Museum of Natural History Hayden Planetarium, and C. R. O'Dell; George Crumb; Serge Marquie; P.P.O.W., New York; Team Gallery, New York; Jack Shear, Spencertown, New York; The Rachofsky Collection, Dallas, Texas; Pace/MacGill Gallery, New York; Billy Renkl; Anne and William Palmer, New York; Greenberg Van Doren Gallery, New York; Williams College Museum of Art, Williamstown, Massachusetts; Feature Inc., New York; and Electronic Arts Intermix, New York.

Thanks to all of the artists included in the exhibition, especially Karel Arm, Russell Crotty, and John Torreano for their participation in this catalog.

The exhibition began with an ambitious multi-media performance o George Crumb's *Makrokosmos III*. Debra Fernandez was our collaborator and choreographer on that great success. We also thank Kim Vanyo, Tarvis Watson, Steve Dinyer, Lucas Chute, Patrick O'Rourke, Patty Pawliczak, and Janet Simone fo their help. Thanks to musicians: Richard Albagli, Dick Hihn, David Porter, and Scott Stacey; actors: David Barlow, Jesse Hawley, Valerie Issembert, David Pilot and James Stanley; and dancers: Francesca Eishenhauer, Julie Gedalecia, Devir Johnson, Sam Johnson, and Melissa Pomeroy. Also performing were students ir Debra Fernandez's Fall 2005 Contemporary Dance Workshop: Alison Berg Marissa Carr, Alicia McGaw Doyle, Zahra Garrett, Ellen Goldstein, Catlin Hinz Dyani Johns, Sasha Lehrer, Mark Schau, Carolyn Seiden, and Lucy Struever. The performance was funded in part by the Skidmore College Dean of the Faculty's Office, the Skidmore College Dance Department and The Margaret Paulding Fund

At the Tang Museum incoming Director John Weber consistently sup ported our work, and the entire staff helped to make it happen. Thanks to Liz BoyKin, Ginger Ertz, Lori Geraghty, Elizabeth Karp, Susi Kerr, Gayle King, Chris Kobuskie, Patrick O' Rourke, Barbara Schrade, Gretchen Wagner and Nicholas Warner. Our installation crew built another amazing environment in record time— thanks to Sam Coe, Abraham Ferraro, Torrance Fish, Jefferson Nelson, and Alex Roediger. Curatorial Assistant Ginny Kollak, deserves special thanks for her close editing and fact-checking of this book, and her careful assistance throughout the entire project. She was assisted by museum interns Megan Isaacs '07 and Benjamin Loesser '05.

This astronomically-inspired catalogue is a document that we hope will be used for years to come. We are thankful for the creative and diligent work of design ers Barbara Glauber, Beverly Joel, and Emily Lessard of Heavy Meta, New York; pho ographer Arthur Evans; and printer Christian Hotte of Transcontinental Litho Acme, Montreal, Canada. Special thanks to Margaret Geller and Scott Kenyon and

Matthew Wilson, Skidmore class of 2006, for their insightful essays. Also thanks to Jay Rogoff for his editing and Martin Benjamin for his performance photography.

Many other individuals helped along the way. For their support and work on the exhibition we thank J. Shermeta for his design of the aluminum frame and Alison Doane at the Harvard College Observatory for her research and keen knowledge of the collection given freely throughout the course of our explorations. We also thank Marion Goethals, Diane Hart, Hudson, Sima Familant, Afshaan Rahman, John Brueggemann, Sarah Goodwin, Stephanie Waite, Mary Ann Foley, Tom O'Connell, Barbara Melville, Mary Jo Driscoll, and Steve Clark. Special thanks to Steven Bruns, Assistant Professor of Music Theory, University of Colorado at Boulder, and Wayne Hammond, Assistant Libarian, Chapin Library, Williams College for their invaluable assistance with George Crumb's archives and Jay Pasachoff's atlases, respectively.

This exhibition was made possible with support from Beverly P. and R. Lawrence St. Clair, the Nathalie Potter Voorhees '45 Memorial Fund, and the Friends of the Tang.

Margo would like to thank Pilchuk Glass School for Visiting Artist Residency and especially gaffers Michael Scheiner and Chris Taylor.

With great admiration we would like to thank David Porter, President Emeritus of Skidmore and our collaborator on this project. David's suggestion of a Crumb performance in the Tang galleries started us on our journey and we are most grateful for his energy, ideas, and encouragement.

IAN BERRY, MARGO MENSING, AND MARY CRONE ODEKON

CURATORS

This catalogue accompanies
the exhibition *A Very Liquid Heaven*
October 23, 2004–June 5, 2005

**THE FRANCES YOUNG TANG
TEACHING MUSEUM AND
ART GALLERY AT SKIDMORE
COLLEGE**
815 North Broadway
Saratoga Springs, New York 12866
T 518-580-8080
F 518-580-5069
www.skidmore.edu/tang

Designed by Barbara Glauber,
Beverly Joel, and Emily
Lessard/Heavy Meta, New York
Printed in Canada by
Transcontinental Litho Acme

ON THE COVER
Johann Gabriel Doppelmayr
Atlas Coelestis, 1742 (detail)
Leaf size 20 7/8 x 13 inches
Collection of Jay M. Pasachoff

PAGE 1
Karen Arm
Untitled [incense #4], 2004 (detail)
Acrylic on canvas
Courtesy of the artist and P.P.O.W.,
New York

PAGES 2–3
Russell Crotty
Atlas of Deep Sky Drawings, 1997
(detail)
Pencil and ink on paper
The Rachofsky Collection,
Dallas, Texas

PAGES 4–5
Margo Mensing
*Collection of Edwin Hubble: Fourteen
Pipes*, 2003 (detail)
Glass
Courtesy of the artist

PAGE 6
Charles and Ray Eames
Powers of Ten, 1977
Installation view, *A Very Liquid Heaven*
Tang Museum, Skidmore College